FORGOTTEN
HEROES & VILLAINS
OF SAND CREEK

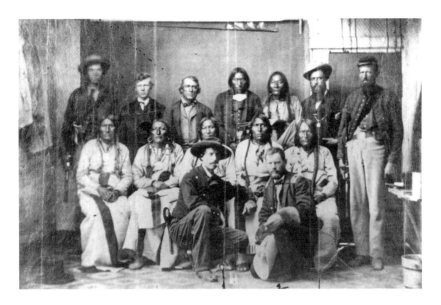

Group portrait from the Camp Weld Council. *Seated in middle row, left to right*: White Antelope, Bull Bear, Black Kettle, Neva and No-ta-nee. *Kneeling in front, left to right*: Wynkoop and Soule. Interpreter John Smith is standing in back, third from left. *Denver Public Library, Western History Collection, call number X-32079.*

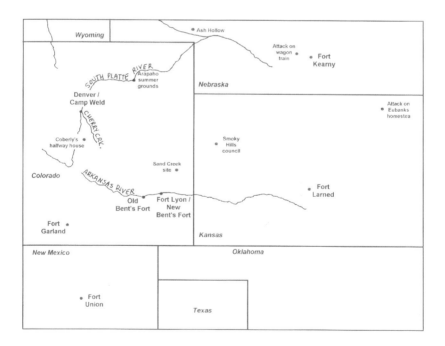

The Cheyennes and Arapahos roamed the high plains east of the Rockies, primarily in Colorado, Kansas and Nebraska.

FORGOTTEN
HEROES & VILLAINS
OF **SAND
CREEK**

C A R O L T U R N E R

Charleston London

THE
History
PRESS

Published by The History Press
Charleston, SC 29403
www.historypress.net

Cover images: The painting was produced by Lynn Turner, and all other images are courtesy of the Library of Congress, Prints & Photographs Division.

First published 2010

Manufactured in the United States

ISBN 978.1.59629.943.6

Turner, C. A. (Carol A.)
The forgotten heroes and villains of Sand Creek / Carol Turner.
p. cm.
Includes bibliographical references.
ISBN 978-1-59629-943-6
1. Sand Creek Massacre, Colo., 1864. I. Title.
E83.863.T87 2010
973.7'37--dc22
2010015719

For John and Lynn, with love.

CONTENTS

ACKNOWLEDGEMENTS

Many thanks to Byron Strom, descendant of Silas Soule's brother, William Soule, and keeper of the Soule flame. Byron's generosity of spirit is inspiring. Thanks also to Vicki Casteel, who shared her many historical documents and thoughtful insights with me about the characters involved in this drama. I owe Vicki particular thanks for tracking down the grave of Joseph Cramer. I also owe many thanks to Barbara Gay, Dana Younger (a distant cousin of Samuel Tappan), Sharon Crowder, Garry O'Hara at Riverside Cemetery, Molly McGarry, Criss Clinton (aka Jim-Criss), Richard Turner, Lynn Turner and John Turner.

Introduction

During the years of the Civil War, Colorado was embroiled in its own battle: the struggle between the increasing waves of white settlers and the tribes who lived in the region. Both sides were deeply divided within themselves—some worked tirelessly to find a way to coexist peacefully; others wanted total war. At a moment when the peacemakers thought they had found a way forward, those who preferred the violent solution intervened.

These are the stories of fourteen people whose lives intersected over the most infamous event in Colorado history: the massacre of Cheyenne and Arapaho Indians at Sand Creek.

CHIEF LEFT HAND

Gifted in languages and marked by a rich curiosity about the white world, Left Hand was a man ahead of his time. He possessed a clarity of foresight that few around him shared and an unrelenting pragmatism that informed every action he took. Long before others realized the truth, Left Hand understood that there was an endless supply of white settlers and that his small tribe would either adapt or face annihilation. Against all evidence to the contrary, he never gave up hope that it could be the former instead of the latter.

Born in a Southern Arapaho village in the 1820s, he grew up riding, hunting and raiding the traditional enemies of the Arapahos, such as the Utes. Called Niwot in the Arapaho tongue, he had a brother, Neva, and an older sister, MaHom, with whom he remained closely tied throughout his life.

Had it not been for MaHom's marriage to a white man, perhaps Left Hand might have lived a more typical life. As many around him did, he might have developed a hatred for the invaders and died on the plains, fighting to keep them out. But that was not his fate. As he entered adolescence, his teenage sister married a white trader who worked for William Bent, owner of Bent's Fort. MaHom's husband, John Poisal, lived with the Arapahos and took an interest in his wife's two brothers. Poisal taught them both English. While Neva learned the basics, Left Hand became adept with the strange tongue. By mingling with their allied tribes on the plains, the Cheyennes and Sioux, he learned their languages as well. Throughout his life, he served as interpreter between these tribes and the whites.

Sometime in his twenties, Left Hand married, but his wife's name is unknown. Nothing is known about their children, and no pictures exist of Left Hand or his wife and children. One pioneer described Left Hand as

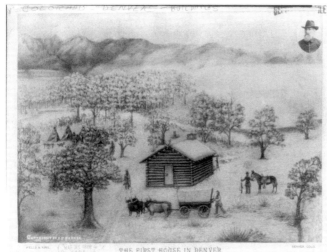

The supposed first house in Denver, built by A.H. Barker near lodges of John Poisal and MaHom, sister of Left Hand, 1858. *Library of Congress, Prints & Photographs Division.*

"the finest looking Indian I have ever seen. He was over six feet tall, of muscular build and much more intelligent than the average Indian."[1] Left Hand became an Arapaho chief sometime during the 1850s, and his name began to appear in the newspapers and other documents of the day. Because of his language skills, he became a spokesman for the Arapahos.

In 1863, the main Arapaho chief, Little Raven, refused to accompany a delegation to Washington, D.C., when they departed for the east before Left Hand could join them. Little Raven did not trust the interpreter John Smith, who had been accused of selling the tribes their own annuities and misrepresenting their statements.

Left Hand's family became further connected with the whites when his niece, Margaret, the daughter of MaHom and John Poisal, married the respected Indian agent Thomas Fitzpatrick. Fitzpatrick was instrumental in organizing the Fort Laramie Treaty of 1851, which gave the Southern Arapaho and Cheyenne tribes legal rights to the territory between the South Platte and Arkansas Rivers.

The 1850s brought hard times to the Arapahos. The once abundant herds of buffalo and antelope grew more difficult to find as wagon trains and stagecoaches moved across the plains to California. The tribes became dependent on the government annuities promised in the Fort Laramie Treaty, but deliveries were sporadic. When the U.S. Senate decided that the terms were too generous and cut the annuities from fifty years to fifteen, the chiefs signed with barely a protest.

Starvation, cholera and smallpox took their toll during the decade, along with the devastating effects of whiskey. As early as 1834, the federal government had outlawed the sale of whiskey to Indians, but plenty of white traders still made good bargains, exchanging the stuff for buffalo hides and beaver pelts.

In 1858, the year the Pikes Peak gold rush began, Left Hand did something extraordinary. Determined to find out as much as he could about the white world, he packed his wife and children into a horse-drawn wagon and headed east into Nebraska and Iowa.

During this journey, Left Hand noted the gold rush excitement running like electricity through frontier communities, and he must have realized what it meant for his tribe.

On his return trip, he traveled for several weeks with a group of pioneers that included a man named Marshall Cook. Left Hand had hailed the wagon train and suggested that they travel together. Cook, who wrote a diary about his experiences, described one morning when Left Hand killed a buffalo for the group:

> We had proceeded but a short distance when a band of buffalo crossed the road a quarter of a mile in advance of the train—great excitement prevailed among those of the party that had not witnessed the Sight of buffalo running at large in a wild state, and even Lefthand caught the incentive and handed the reins of his team to Mrs. [L]efthand, and jumped out of the wagon so lightly as a boy in his teens, placing three fingers of his right hand to his mouth, blew a Shrill whistle which brought War Eagle, the extra pony before mentioned to his side, then mounting it without bridal or Saddle, with a Single barrel Shotgun in his hand, loaded with an ounce ball, he signaled his being ready when the pony darted away on a quick gallop, appearantly [sic] eager for the chase. The Indians feet keeping time with the motion of the pony, fanning in and out like the wings of a huge bird, when on flight near the ground, and as they approached the fleeting buffalo, the pony increased his speed until he appeared almost to fly, a short run at the speed he was going, soon brought its rider along side of a fine fat cow and also within a few yards of her. When [L]efthand fired the pony dashed away to avoid being gored by the wounded brute—circling around the faithful charger brought its rider again along side of the maddened animal. The Indian in the interim had reloaded his gun, being now near to the wounded buffalo which had lagged behind the herd from the effect of the shot; the Indian fired the Second time which brought down the huge animal the monarch of the plains.[2]

Cook enjoyed his conversations with Left Hand, who told him that farming was probably not suitable for his people but that he felt sure they would make excellent cattle ranchers.

The rush of settlers and gold seekers quickly overran the traditional wintering grounds of the Arapahos and Cheyennes—today's Denver-Boulder area. For a time, the tribes coexisted with the whites, pitching their buffalo skin lodges near the ramshackle wooden cabins that were popping up along the region's creeks. For Left Hand, this practice came to an abrupt end on a spring night in 1860. Knowing that the men were out on a hunt, a notorious thug nicknamed "Big Phil the Cannibal" led a group of drunken whites over to Left Hand's camp near Cherry Creek. They forced their way into Arapaho lodges and raped a number of Arapaho women. One of the victims was Left Hand's sister MaHom, as well as possibly his wife and nine-year-old daughter.

This outrage was reported to the *Rocky Mountain News* by a longtime resident of the region, the trader and trapper Jim Beckwourth. An outcry sounded over the muddy streets, but nothing came of it. When Left Hand returned and learned what happened, Beckwourth convinced him to take no revenge. By now, the balance had shifted and the whites outnumbered the Indians.

Although Left Hand restrained himself and managed for the time being to control the men in his band, he faced growing pressure from within. He and other chiefs were middle-aged now, counseling peace while the tribes' warriors became increasingly angry. Many of the younger men wanted to prove themselves and fight the encroachment and outright theft of their lands.

As food became harder to find, small bands began raiding white settlements and stage stops, stealing cattle and horses. Left Hand developed a policy of warning white settlers whenever he heard rumors of a planned raid. Some in his tribe must have despised him for this, but he persisted with the same argument—they were outnumbered and could not win a war against the whites.

Left Hand made other efforts to integrate with the whites. In January 1861, when the citizens of Denver held one of their many elections, Left Hand again did something entirely unexpected, as reported in the newspaper:

> *"Left Hand" chief of the Arapahoe tribe, and one or two of his braves, attended the polls on Saturday last, and offered their votes, which were refused, probably on the ground that their property was not subject to taxation.*[3]

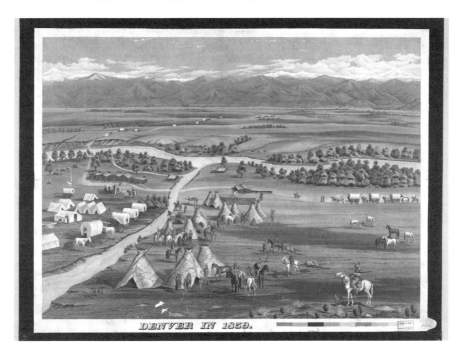

Denver in 1859. *Library of Congress, Prints & Photographs Division.*

Although they had not allowed him to vote, Left Hand made another appeal later that year. In April, he showed up at Denver's Apollo Theater to attend a performance. When the program ended, he got up and made a plea to the audience. Again the incident was described in the newspaper:

> *There was a fine audience last night at the Apollo. The Amateur and Professional actors acquitted themselves admirably in the lady of Lyons and the afterpiece. Left Hand and a score of his brethren were present. In his vernacular, the Arapahoe Chief makes a handsome speech. He wished his white brethren would stop talking about fighting with his people, because his people had no enmity against them whatever—but looked on them as brethren.*[4]

The same week, Little Raven, Left Hand and two other sub-chiefs, Storm and Shave Head, met with leading whites in the office of the latest Indian agent, who had replaced Fitzpatrick when he died. Little Raven made an impassioned speech for peace, promising to treat the whites "kindly" and asking the same from them. He pointed out that "their game had become scarce, and they were compelled at times to ask for food from the whites."[5]

The year 1862 was a quiet but desperate time for the Arapahos, as they hunted for food, battled smallpox and tried to avoid the inevitable troubles brought on by interacting with the whites. One Arapaho sub-chief known as Big Mouth robbed a Mexican wagon train and stole some whiskey, but otherwise there was little activity.

The situation grew steadily worse over the next two years. In 1864, Colonel John Chivington, military commander of Colorado, stepped up the hunt for cattle rustlers. This resulted in several skirmishes that served only to escalate tensions—most notably the unprovoked shooting of Lean Bear, a revered Cheyenne chief. Lean Bear had been among a delegation of chiefs that journeyed to Washington, D.C., in the spring of 1863 to visit President Lincoln. There, Lincoln encouraged them to give up their nomadic lifestyle and learn how to be farmers. Left Hand was supposed to join the Cheyennes on this trip, but both he and Little Raven ended up not going.

A year later, in May 1864, Lean Bear's band was camped on the Smoky Hill River. Notified that a column of soldiers was approaching, Lean Bear and a large group rode out to meet them. As the Cheyennes approached, the soldiers went into formation. Lean Bear rode forward with another man, named Star, displaying the peace medal and document that President Lincoln had given him during his visit. As Lean Bear and Star drew near, an officer ordered the soldiers to fire. Both Lean Bear and Star were killed, and their bodies were then riddled with bullets as they lay on the ground. Later that year at the Camp Weld Council, Cheyenne chief White Antelope told Governor Evans that this unprovoked shooting of Lean Bear marked the beginning of hostilities.

That summer, a Kiowa chief called Satanta raided Fort Larned in Kansas and made off with a herd of horses. When Left Hand heard about it, he approached the fort and delivered an offer to help retrieve the stock. His intent was to remind the soldiers that the hostile acts of one group did not mean that all bands were to blame. Unfortunately, the commander of Fort Larned at that time was a notorious drunk named Captain J.W. Parmeter. In response, he ordered his soldiers to fire a howitzer at Left Hand, his band and their white flag.

This was the last straw for many of Left Hand's warriors, and he later told another new Indian agent, Samuel Colley, that he could not control them after this attempt on his life. Many young Arapahos joined Cheyenne raids against the whites that summer, during what became known as the Cheyenne War of 1864. These attacks shut down the stage and freight routes for some months. The residents of Denver, upset that mail and merchandise no longer arrived from the east, also felt terrified that they'd been cut off from civilization.

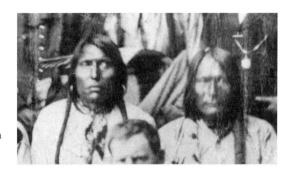

Left Hand's brother, Neva (left), and cousin, No-ta-nee. No known pictures exist of Left Hand. *Denver Public Library.*

Despite these pressures, Left Hand never wavered in his efforts to make peace. At the Smoky Hill Council in September 1864, he told Major Ned Wynkoop about the incident at Fort Larned when Parmeter fired on him but also said that he would still refuse to fight the whites.

Left Hand did not attend the Camp Weld Council in October 1864—perhaps because he was ill or maybe to keep an eye on the young men of his band while the peace talks were going on. His brother Neva went in his place, along with Left Hand's cousin, Arapaho sub-chief No-ta-nee. Little Raven did not attend either. He was still suspicious of the whites and said so during the Smoky Hill Council.

As discussed at Camp Weld, about 650 Arapahos arrived in the Fort Lyon area that November. Stories circulated that some of the men in Little Raven's camp were responsible for killing two whites in the Arkansas Valley. Little Raven still distrusted the soldiers, and he and most of the Arapahos—about 600 of the tribe, including Neva—did not go to the camp at Sand Creek. This distrust saved his life and the lives of much of the Arapaho tribe.

Left Hand chose to stay with Cheyenne chief Black Kettle. With him were his wife and children, his sister MaHom (now the widow of John), her daughter Mary Poisal and No-ta-nee, his cousin who had attended Camp Weld.

When the Colorado Cavalry attacked the camp at Sand Creek, Left Hand's band was virtually annihilated, including his wife and children. Only 4 Arapahos out of 50 or 60 escaped, including MaHom and her daughter Mary Poisal. Other escapees carried a severely injured Left Hand into the Smoky Hill camp. He soon died of his injuries, having been spared the mutilations visited on the bodies of No-ta-nee, Cheyenne chiefs White Antelope and One Eye and the rest of the 175 or so Cheyennes and Arapahos killed at Sand Creek.

Chief Left Hand, who never fought the whites, died in the cause of peace. The town of Niwot, Colorado, is named for him, as are Left Hand Canyon and Left Hand Creek in western Boulder County.

Major Edward Wynkoop

Brash, good-looking and ambitious, Edward "Ned" Wynkoop started out as one of frontier Denver's "bad boys," chumming around with actors, rebels and gunmen. Later, as commander of Fort Lyon for the First Colorado Cavalry, he underwent an abrupt and radical transformation. He put his career, his life and the lives of his men on the line in an audacious attempt to bring peace to Colorado Territory.

Born in Philadelphia in 1836, Edward Wynkoop came from a prominent family of politicos and industrialists. He headed west to Kansas Territory at the age of twenty, where he remained carefully neutral in the antislavery versus proslavery battle that tore at every Kansas town. He focused his energies on cultivating political connections, including a friendship with the new Kansas territorial governor, James Denver.

When rumors of Pikes Peak gold swept across Kansas and the rest of the United States, Governor Denver and a group of Kansas officials and businessmen, including Wynkoop, decided to establish a new city in that unknown wilderness. For them, it was a commercial venture, an attempt to get in on the ground floor of potentially astronomical profits. Wynkoop and his party set off for the Rocky Mountains and arrived at Cherry Creek on November 16, 1858. They were among the first to settle what eventually became Denver.

At that time, the southern front range of the Rockies was part of Kansas Territory, while everything north of Baseline Road in today's Boulder was part of Nebraska Territory. With the simultaneous arrival of several groups, squabbles quickly arose about who started which city first and who was in charge. Before the Wynkoop group left Kansas, Governor Denver had—

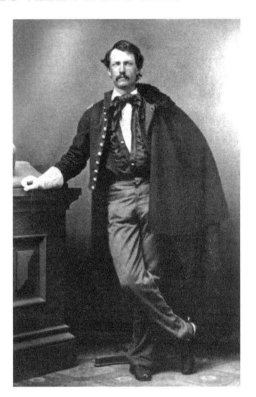

Right: Portrait of Edward (Ned) Wynkoop, taken by George Wakely, the stepfather of Louise Wynkoop, 1861. *Denver Public Library, Western History Collection, call number X-22195.*

Below: Pioneers crossing the Cache la Poudre River, near present-day Fort Collins. *Drawing by Daniel A. Jenks, 1859. Library of Congress, Prints & Photographs Division.*

perhaps a bit prematurely—appointed Wynkoop sheriff. Wynkoop had not even been on Cherry Creek for a month when he turned around and journeyed back to Kansas to lobby for a city charter from officials there. These efforts failed, however, when the Kansas legislature issued the charter to a rival group.

During his stay in Kansas, Wynkoop made exuberant claims about the riches to be had at Cherry Creek. When he headed west again, he encountered more than a few would-be millionaires returning empty-handed to Kansas. At one point, he "came near becoming a victim of lynch law; but the very fact of my returning to the country which they considered a hum-bug acted in my favor…[and] some of the cooler heads of the infuriated mob viewed my case in the above light."[6]

The new settlement grew as energetic pioneers built saloons, inns, general stores, blacksmiths, brick-making operations, schools, churches and theatres. Wynkoop's appointment as sheriff had not survived the incorporation of Denver City, but he was later elected sheriff proper. He also had stints as a miner, bartender and actor. He starred in several dramas staged by the Denver Amateur Dramatic Association (of which he was president).

One of the first entertainment establishments in Denver was the Apollo Hall. A saloon operated downstairs, while upstairs served as a meeting space and candlelit theatre. September 15, 1859, saw Denver's first dance performance there. One of the "Thorne's Star Company's" brightest stars was the beautiful dancer/songstress Louise Brown. Along with half of the men in Denver, Wynkoop fell in love and wooed her. Despite her many suitors, Louise chose the tall, clever Wynkoop, and on August 21, 1861, the two married.

By all accounts, Wynkoop settled down considerably under Louise's influence. Three weeks before their wedding, he had enlisted in the Colorado Cavalry. The couple eventually had eight children, all of whom accompanied their parents to many isolated and rugged outposts in the western frontier.

In 1862, the cavalry was ordered to march south to New Mexico and assist Union colonel Edward Canby in his fight against invading Confederates from Texas. The *Rocky Mountain News* proudly announced the orders, incorrectly noting that Ned Wynkoop would be in command:

We are glad that an opportunity is at last offered to our brave Colorado boys to "do or die" for their country: knowing as we do that they longed for action, and will acquit themselves with honor. Capt. Wynkoop, as senior captain will have command, and all who know Ned, know that what he sets out to do, will be well done.[7]

The Apollo Hall in Denver, where Louise Brown danced and sang on the stage upstairs. *Drawing by Richard Turner.*

Wynkoop's company under Major John M. Chivington took part in the Battle of Glorieta Pass. Wynkoop served well and was promoted to major.

Back in Colorado in 1863, Wynkoop spent the summer fruitlessly chasing elusive bands of Utes who were stealing stock from the Overland Stage Line. At this time, the official policy was still to use "great caution" to avoid fights with "any party of Indians who are peacefully disposed."[8] The following spring, Wynkoop was sent south to take command of Fort Lyon. His job was to protect immigrants and wagon trains traveling through the region on the Santa Fe Trail. This period saw increased attacks, and instructions from Chivington changed: "See that herds of public stock are properly guarded. The Cheyennes will have to be soundly whipped before they will be quiet. If any of them are caught in your vicinity kill them, as that is the only way."[9]

In June, Wynkoop received word of the "approach of a body of Texans toward this post,"[10] which created a flurry of activity among the troops. The "Texans" were later discovered to be outlaws known as the Reynold's Gang, but the outposts in the region remained on alert for Rebel invaders from Texas for the duration of the Civil War.

That summer, groups of Kiowas under Chief Satanta attacked a couple of trains and a homestead near Bent's place. Wynkoop took three companies into the field in search of Satanta but returned empty-handed.

Meanwhile, a defiant and bellicose young Arapaho, the son of Chief Little Raven, attacked a stagecoach, killed two men and kidnapped a woman named Mrs. Snyder. Two other whites were subsequently found murdered and scalped eighteen miles from Fort Lyon. Nebraska and Kansas suffered worse attacks, including one on a wagon train and another on a homestead settled by a family named Eubanks. In these episodes, the raiders kidnapped half a dozen women and children.

The entire region went into a state of high alert, and even the famous William Bent of Bent's Fort thought about leaving the area.

In the midst of this volatile situation, Cheyenne chief One Eye and his small party rode up to Fort Lyon with a letter from Chief Black Kettle. When a soldier brought One Eye into the fort, Wynkoop was angry at first. As he wrote years later in his autobiography:

> *I reprimanded the Sergeant for taking prisoners, reminding him of the existing order* [to shoot on sight], *in his defense he stated that while in the act of firing he observed one of the Indians hold up a paper and make signs of peace; that in consequence he held his fire and thought he had better bring them to me instead of putting them to death.*[11]

Even more miraculous than the fact that One Eye and his party were not shot on sight, Wynkoop experienced a complete change of heart during his meeting with the old chief. The persuasive One Eye convinced Wynkoop to visit the Cheyenne and Arapaho camp and talk peace. Within two days, Wynkoop had organized 130 troops, plus two mountain howitzers, and set out for a five-day journey to a large encampment of Cheyennes and Arapahos on the Smoky Hill River in Kansas over one hundred miles away.

After they arrived, Wynkoop listened to what the chiefs had to say, while several of his nervous officers talked mutiny. He also took charge of four white children who had been taken hostage that summer in Nebraska and Kansas. He told the chiefs that he couldn't make peace with them but that he

would escort them to Denver for a meeting with those who could—Colonel Chivington and Governor John Evans.

Wynkoop later realized that this was his mistake. The southern Colorado region, including Fort Lyon, had recently switched military districts. Wynkoop's command headquarters was now in Kansas, not in Denver.

Nevertheless, Wynkoop, Captain Silas Soule, Lieutenant Joseph Cramer and some men, along with interpreter John Smith, escorted a group of chiefs north. Wynkoop rode ahead to inform Governor Evans, who was annoyed at the news and reluctant to meet. Wynkoop finally prevailed upon Evans to attend the meeting, but instead of offering terms for peace, Evans grilled the chiefs about recent attacks and showed no interest in hearing their side of the story. Both Evans and Chivington basically washed their hands of the issue and stated that Major Wynkoop would decide what to do.

After Camp Weld, Wynkoop and his officers returned to Fort Lyon along with the chiefs. The chiefs then left to bring their bands to camp near the fort. Wynkoop sent a messenger to General Curtis at Leavenworth describing what happened. Pointing out that he did not have enough troops for a war with the tribes, he asked for instructions.

Wynkoop was unpleasantly surprised when, on November 4, Major Scott Anthony arrived with orders to take over command of Fort Lyon and a letter telling Wynkoop to report at once to district headquarters in Kansas.

Before leaving, Wynkoop obtained assurances from Major Anthony that he would continue the same policies toward the Arapahos and Cheyennes that were now camped near the fort at Wynkoop's behest. He then set about gathering documentation in support of his actions. Lieutenant Joseph Cramer, assigned to Fort Lyon, wrote a letter of support for Wynkoop to take with him:

Dear Sir: Having learned with regret that you have been relieved and ordered to Fort Leavenworth to report your official proceedings in regard to Indians while in command of this post, I cannot let the opportunity pass without bearing testimony to the fact that the course adopted and carried out by you was the only proper one to pursue, and has been the means of saving the lives of hundreds of men, women, and children, as well as thousands of dollars' worth of property.

No one can doubt that the lively aid rendered by you (at the risk of your own life as well as the lives of your small command) to the captives among the Arapahoes and Cheyenne Indians, was also the means of saving their lives. For this act alone (even if you had not done more) you should receive the warmest thanks of all men, whether in military or civil life.

Your visit to Denver with some of the principal chiefs of the Arapahoe and Cheyenne tribes was productive of more good to the Indians, and did more to allay the fears of the inhabitants in the Arkansas valley, than all that has been done by all other persons in this portion of the department.

Since that time no depredations have been committed by these tribes, and the people have returned to their houses and farms, and are now living as quietly and peaceably as if the bloody scenes of the past summer had never been enacted.

Hoping that in all things your course will be approved by the commander of this department, and that you will soon be restored to your command in this district, I remain your obedient servant, Joseph A. Cramer, Second Lieut. First Cavalry of Colorado, Commanding Co. K.[12]

This letter was signed by all eight officers at Fort Lyon and was endorsed by the incoming commander, Major Scott Anthony.

Wynkoop had another letter from "We, the undersigned, citizens of the Arkansas Valley, of Colorado Territory." In this letter, they commended Wynkoop's bravery in rescuing the prisoners and his peacemaking efforts, stating that they "desire to express to you our hearty sympathy in your laudable efforts to prevent further danger and bloodshed, and sincerely congratulate you in your noble efforts to do what we consider right, politic, and just, whether those efforts on your part prove successful or not."[13]

This letter was signed by twenty-seven citizens of the Arkansas Valley, including Charles Autubees (or Autobees), who had lost a large number of cattle to Indian raids.

As ordered, Wynkoop proceeded to Kansas, where he met with General Curtis who, Wynkoop later testified,

censured me not for the course I had adopted with the Indians particularly, but for committing an unmilitary act by leaving my district without orders and proceeding to Denver City with the Indian chiefs and white captives to the governor of Colorado instead of coming to himself, and asked what explanation I had to make. I told him that I had since become pretty well convinced that I had made a mistake, but that at the time I thought that Governor Evans was the proper person to refer that matter to, he being governor of Colorado Territory and ex officio Indian superintendent.[14]

Two days after Wynkoop left Fort Lyon, Colonel John Chivington arrived with eight hundred temporary Colorado troops known as the one hundred

days' men, or the Colorado Third Cavalry. Chivington prevailed upon Major Anthony to order his men to join them in a surprise attack at Sand Creek.

Wynkoop was horrified and enraged when he learned of these events from letters sent to him by Lieutenant Joseph Cramer and Captain Silas Soule. Both letters detailed the many depraved acts committed by Chivington's untrained and undisciplined troops. Soule wrote:

> *The massacre lasted six or eight hours, and a good many Indians escaped. I tell you Ned it was hard to see little children on their knees have their brains beat out by men professing to be civilized. One squaw was wounded and a fellow took a hatchet to finish her, she held her arms up to defend her, and he cut one arm off, and held the other with one hand and dashed the hatchet through her brain. One Squaw with her two children, were on their knees, begging for their lives of a dozen soldiers, within ten feet of them all firing—when one succeeded in hitting the squaw in the thigh, when she took a knife and cut the throats of both children, and then killed herself. One old Squaw hung herself in the lodge—there was not enough room for her to hang and she held up her knees and choked herself to death. Some tried to escape on the Prairie, but most of them were run down by horsemen. I saw two Indians hold one of anothers hands, chased until they were exhausted, when they kneeled down, and clasped each other around the neck and were both shot together. They were all scalped, and as high as half a dozen taken from one head. They were all horribly mutilated. One woman was cut open and a child taken out of her, and scalped.*
>
> *White Antelope, War Bonnet and a number of others had Ears and Privates cut off. Squaws snatches were cut out for trophies. You would think it impossible for white men to butcher and mutilate human beings as they did there, but every word I have told you is the truth, which they do not deny. It was almost impossible to save any of them.*[15]

News of the massacre quickly reached Washington, and a month later, on December 31, Wynkoop was ordered back to Fort Lyon to replace Major Anthony and conduct an investigation. When he arrived, he took statements from the officers, all of whom denounced the attack. Three formal investigations followed, condemning Chivington for the massacre. Unfortunately, the damage was done. All of the "peace chiefs" were either dead or disgraced among their own, and the warrior clans began a war of retribution.

For the next few years, Edward Wynkoop acted as agent to the Cheyennes and Arapahos. In 1866, he was promoted to brevet lieutenant-colonel. Though he continued his efforts to broker a peace settlement, the process was tricky and dangerous. Many Cheyennes and Arapahos wondered if he had set them up for the massacre. An anonymous column in the *Rocky Mountain News* (possibly by Chivington) vilified Wynkoop, noting, "The words and oaths of some men are always worthless, and partially aware of the fact, they tell as large a falsehood as possible. Wynkoop is such a man." The writer went on to decry any efforts to "supply these savages, whose belts are ornamented with white scalps, and whose hands are red with blood, with powder and lead, with clothes and provision."[16]

Wynkoop worked hard to rebuild trust among the tribes, and he had his supporters among the whites. He developed a deep friendship with Cheyenne chief Black Kettle, who also continued working for peace. However, Wynkoop grew increasingly frustrated. On November 29, 1868—two days after George Armstrong Custer's attack at Washita—Wynkoop resigned his commission as agent. His resignation letter cites the movement of troops toward Washita, but he apparently had not yet heard of the attack that killed his good friend Black Kettle.

In a letter to his friend Samuel Tappan in January 1869, he wrote in frustration, "I will be damned if I don't desert my country forswear Christianity and become a Mahometan if this state of affairs continue."[17]

After Wynkoop's resignation, the family moved back east to Philadelphia for several years and then returned in 1874 to New Mexico. There, Wynkoop served as adjutant general and later became a prison warden.

Edward Wynkoop died at age fifty-five in Santa Fe in 1891 of a kidney condition that may have originated from injuries he received when he was thrown from his horse at Silas Soule's funeral procession. His obituary stated that he was "one of the finest pistol shots in the world."[18]

He was survived by his wife, Louise, five sons and three daughters. After Ned's death, Louise and the children moved back to Denver, where they were neighbors of John Chivington.

Governor John Evans

When John Evans arrived in the Colorado Territory, he came as a wealthy and influential Chicago businessman who had been appointed governor by President Lincoln. Already a millionaire, Evans saw Colorado as a boundless opportunity for the development of towns and railroads and, of course, unimaginable wealth for those who made it happen.

Born on an Ohio farm in 1814, the ambitious Evans graduated from a two-year medical school in Cincinnati and then moved on to Indianapolis, where he helped establish one of the country's first insane asylums and a school for the deaf. Tall and attractive, Evans must have been considered a good catch. At twenty-four, he married Hannah Canby. During the next twelve years, three of their four children died of tuberculosis. In 1848, they moved to Chicago, a boomtown of twelve thousand people—the largest on the frontier. There he taught medical school and grew rich from real estate and railroad investments. In 1850, Hannah also died of tuberculosis. The same year, Evans and others founded Northwestern University and the town of Evanston, Illinois, which was named for him.

Three years later, Evans married Margaret Patten Gray. They had four children together, three of whom survived. By now, Evans had given up his medical practice and teaching, devoting all of his energies to his investments.

John Evans was an early supporter of Abraham Lincoln during his bid for the presidency, and the two became friends. After removing Colorado Territory's first governor, William Gilpin, President Lincoln offered the governorship to Evans.

Evans was a good businessman and was more practical than Gilpin. He worked hard for years to bring the railroad into Denver. From early on,

The first offices of the
Rocky Mountain News.
*Drawing by Richard
Turner.*

he developed close ties with two other prominent citizens: William Byers, editor of the *Rocky Mountain News*, and Colorado's military commander, John Chivington. Evans and Chivington founded the Colorado Seminary, which became the University of Denver.

Evans was less successful in his dealings with the Arapahos and Cheyennes. Along with his appointment as governor, he was also named ex-officio superintendent of Indian affairs, two positions whose interests were naturally opposed. As governor, he had a duty to protect citizens, but the superintendent of Indian affairs was supposed to be concerned with the interests of the tribes. Evans troubled himself very little over this dilemma. For him, the tribes represented obstacles to the development of railroads and to civilization in general. He felt it was ridiculous that such huge swaths of territory should belong to a "few bands of roving Indians, nomadic tribes."[19]

Evans was anxious to enforce the Treaty of Fort Wise, signed in 1860. He wanted the tribes to move to a new reservation in southeast Colorado, which would give the railroad companies safe access to former Indian lands. So far, neither side had made much effort to comply with the treaty.

Late in 1862, word came that the Sioux in Minnesota had gone on a rampage against settlers, killing seven hundred whites. Although relations were still basically peaceful in Colorado, and the whites outnumbered the Cheyennes and Arapahos by ten to one, this news terrified the white population.

The following year saw increased incidents of cattle rustling by Cheyennes, Arapahos and Sioux. Evans heard rumors of a secret plot among the tribes to attack Colorado settlements. Evans notified Union general Schofield in May that "Indians have given notice we must fight or leave. Have just had

report of a big secret conference between Sioux, Arapahoes, and Cheyennes, about 100 miles north. May want our forces strengthened in a few days."[20]

He wrote a similar letter again in June, and more throughout the year, but the military repeatedly told him that every spare soldier was needed in Kansas to fight the Confederacy.

At the end of September, Evans tried to organize a meeting with the chiefs. Due partly to a drought, 1863 was a year of famine and disease on the plains. Most chiefs said that they could not attend the meeting—some were busy with buffalo hunts, while others complained that their horses were too poor to make the journey to the meeting site. Some finally agreed to go, and Evans departed Denver in early September to travel to the chosen location. When his party arrived, only four lodges of Indians were present, so Evans sent a local rancher named Elbridge Gerry to round up the others.

When Gerry finally located Cheyenne chief Black Kettle's camp, they told him that they had to break their promise to attend because whooping cough was running through their camp and thirty-five children had already died.

The exasperated Governor Evans ended up returning to Denver without meeting with the chiefs. There, a report awaited him from Robert North, a white man of highly dubious character. Early Colorado historian George Bird Grinnell reported stories that Robert North was a "'murderous white chief of an outlawed band of the Northern or Big Horn Arapahoes' (supposed to have been insane)…He was accused of assisting in the destruction of ten miners on the Yellowstone…and was leader of the Arapaho contingent of hostiles who assisted at the massacre of the eighty soldiers near Fort Phil Kearny in 1866."[21]

Evans may have been unaware of North's unsavory reputation, but he believed his story that most of the regional tribes—the Comanches, Apaches, Kiowas, Northern Arapahos, Cheyennes and Sioux—were planning a war to drive the whites from the territory. Although the story was later proven false, it fit with what Evans already thought. Evans sent a copy of North's statement to the commissioner of Indian affairs in Washington, saying that he was "fully satisfied with the truthfulness of his statement and have deemed it prudent to make every arrangement to prevent war and to ferret out any step in progress of this foul conspiracy among these poor, degraded wretches."[22] Evans stepped up his pleas for help, but the replies he received from General Curtis continued in the same note—the real war was going on to the east; Kansas was vulnerable to the rebellion; and Colorado not only must make do with local militia but should also send more help to Kansas.

Throughout the spring of 1864, Evans made increasingly frantic entreaties for funds to raise additional troops. In June, an event occurred

that confirmed for Evans all his worst fears and gave him the ammunition he'd been looking for.

Thirty miles southeast of Denver, four Arapaho renegades attacked a small homestead. There they murdered a young woman, Mrs. Ellen Hungate, and her two small children—a four-year-old girl named Laura and a baby girl named Florence. The murders were particularly depraved: they stabbed, scalped and possibly raped Ellen Hungate and then cut the throats of the little girls so deeply that their heads were almost severed. The father, Ward Hungate, who was out looking for strayed stock, saw that his homestead was burning and ran back, only to be slaughtered himself. Historians disagree on why the family was so brutally murdered—previous incidents in the region had been limited to stealing stock. Some said that this was a signal that the war was beginning; others claimed that these particular Arapahos had something personal against Hungate or his boss, a man named Van Wormer.

Either way, someone brought the bodies of the murdered family and put them on display in a shed in Denver, where the townspeople flocked to view the gruesome corpses. A wave of terror rolled through the region. Ranchers and farmers abandoned their homes and hurried into town. Evans sent a frantic wire, notably sketchy in details. This time he bypassed General Curtis and went straight to Secretary of War Edwin Stanton: "One settlement devastated 25 miles east of here; murdered and scalped bodies brought in to-day. Our troops near all gone…Shall I call a regiment of 100-days' men or muster into U.S. service the militia?"[23]

Evans then wrote to Curtis, describing the hundred-day regiment he wanted for fighting the "Indian alliance." He enclosed another statement from Robert North, who now insisted that the Cheyennes, Kiowas and Comanches were plotting to drive out the white man, this time with collusion from New Mexicans.

A few days later, widespread panic engulfed Denver when a rancher galloped through town screaming, "The Indians are coming!" A panicked mob broke into a military ordnance storeroom for weapons, and citizens packed themselves into public buildings. After half a day of silence, the townspeople crept out and eventually determined that the whole thing had been a false alarm.

On June 22, Evans wrote again to Curtis, providing information about stock thefts and again trying to convince him that the situation was desperate:

> *I had supposed that the information I have given you was sufficient to satisfy you that this Indian war is no myth but a terrible reality to a community*

situated as we are, so exposed and so far from our base of supplies, with a scarcity of subsistence already.[24]

A week later, Evans issued a proclamation, which he published in the newspaper. He also sent a copy to Indian Agent Samuel Colley, with instructions to get the message out:

To the Friendly Indians of the Plains: Agents, interpreters, and traders will inform the friendly Indians of the plains that some members of their tribes have gone to war with the white people. They steal stock and run it off, hoping to escape detection and punishment. In some instances they have attacked and killed soldiers and murdered peaceable citizens. For this the Great Father is angry, and will certainly hunt them out and punish them, but he does not want to injure those who remain friendly to the whites. He desires to protect and take care of them. For this purpose I direct that all friendly Indians keep away from those who are at war, and go to places of safety.[25]

He went on to suggest locations where the friendlies from each tribe should go. For the Arapahos and Cheyennes, he directed them to Fort Lyon, where Agent Colley would provide for them and "show them a place of safety."[26]

As the summer wore on, Evans received additional reports of Indian plans to wage war, and two more Indian attacks were reported, in which three and then two more white men were killed. On July 5, Curtis sent Evans a carefully worded missive, which hinted that he felt Evans was overreacting:

While prepared for the worst as far as possible, we may not exhaust our efforts in pursuit of rumors, and I, therefore, request you to send me telegraphic information of outrages which were fully ascertained.[27]

Curtis pointed out that not only had the Denver area been quiet since the Hungate murders but also that very few incidents actually took place for such a vast territory. He said that "it would take a great deal more force than we now have" to patrol the isolated settlements across Colorado, Nebraska, New Mexico and Kansas.

August saw increased raids around Fort Lyon, most perpetrated by the Kiowas under Chief Satanta. Another reported skirmish later turned out to be Arapaho sub-chief Neva trying to deliver Black Kettle's letter asking for a council to Major Wynkoop at the fort. On August 10, Evans sent a

hyperbolic telegraph to the commissioner of Indian affairs, again bypassing the skeptical General Curtis:

> *I am now satisfied that the tribes of the plains are nearly all combined in this terrible war, as apprehended last winter. It will be the largest Indian war this country ever had, extending from Texas to the British lines, involving nearly all the wild tribes of the plains. Please bring all the force of your department to bear in favor of speedy reenforcement of our troops, and get me authority to raise a regiment of 100-days' mounted men. Our militia law is inoperative and unless this authority is given we will be destroyed.*[28]

The next day, Governor Evans issued a second, less friendly proclamation, which was a call for a citizens militia. He declared that none of the tribes had reported to the places of safety and that he now considered most of the Indian tribes "at war and hostile to the whites." He then authorized and urged the citizens of Colorado to pursue hostile Indians and "to kill and destroy, as enemies of the country, wherever they may be found, all such hostile Indians." He stated that those who would join in this hunt would be given arms and ammunition, would be paid as soldiers, would be allowed to keep whatever property they took and would get a reward for returning any stolen property.[29]

On that day, Governor Evans finally received authority to raise a cavalry that would be enlisted for one hundred days. He and Chivington immediately set to work, recruiting troops from among the unemployed men in Denver and the surrounding mining towns and equipping them for the "largest Indian war this country ever had."

That summer would later be known as the Cheyenne War of 1864. However, nearly all attacks involving the deaths of whites occurred in Kansas and Nebraska—not in Colorado Territory. As it turned out, once the Third Colorado Cavalry of hundred days' men was raised, there was nothing for them to do. Colorado Territory was quiet. In fact, some folks around town jokingly called them the "Bloodless Third."

At the end of September, Major Wynkoop arrived in Denver to tell Evans that the chiefs were coming to talk peace. Evans was not pleased. He told Wynkoop that the Indians had declared war and that it was now a military matter and out of his hands. Even if he could make peace, he didn't think that would be his policy because he had not "punished" the Indians sufficiently and because making peace would mean that the United States was acknowledging that it was "whipped."

In his later testimony about this conversation, Wynkoop described a John Evans whose primary concern was how he looked to officials in Washington, D.C. Evans said, "[A]fter they [the hundred days' men] had been raised and equipped, if peace was made before they had gone into the field, they would suppose at Washington that [Evans] had misrepresented matters, and that there never had been any necessity for the government to go to the expense of raising that regiment; that, therefore, there must be something for the third regiment to do."[30]

Evans finally agreed to attend the council, but he was clearly not interested in talking peace. Instead, he first berated Black Kettle for not appearing at the meeting that Evans had called the previous autumn and then accused him of plotting to make war:

> *Governor Evans, (resuming.) I was under the necessity, after all the trouble and expense I was at, of returning home without seeing them. Instead of this, your people went away and smoked the "war pipe" with our enemies.*
> *Black Kettle. I don't know who could have told you this.*
> *Governor Evans. No matter who said this, but your conduct has proved to my satisfaction that such is the case.*
> *Several Indians. This is a mistake; we have made no alliance with the Sioux or any one else.*[31]

Evans then bluntly told the chiefs that the war between the whites would soon end and that the plains would swarm with troops looking for Indians to fight. He reiterated his proposition that the Indians could come in and show their friendship by helping the soldiers fight their enemies. He handed responsibility for the entire issue over to the military, and to Colonel Chivington, who responded that they should submit to Major Wynkoop.

At the time of the Sand Creek massacre, John Evans was visiting Washington, D.C. During the subsequent investigations, a committee chairman castigated him, calling his testimony "prevarication and shuffling…for the evident purpose of avoiding the admission that he was fully aware that the Indians massacred so brutally at Sand Creek, were then, and had been, actuated by the most friendly feelings towards the whites."[32]

On September 13, 1865, Evans wrote a response. He claimed that the report of the investigation, which consisted mainly of transcribed testimony, was full of "partial, unfair, and erroneous statements." He offered the defense that the committee had no jurisdiction to investigate Indian matters outside

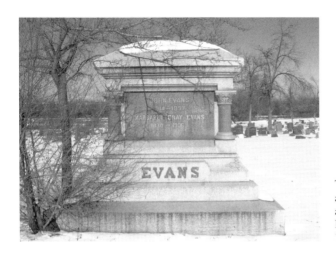

The grave of John and Margaret Evans at Riverside Cemetery, Denver. *Photo by Carol Turner.*

of Sand Creek. Since he was not directly involved in Sand Creek, they had no right to include him in their investigation. He suggested that Black Kettle's group had taken the prisoners themselves instead of trading for them as they claimed. He deconstructed Black Kettle's offer to meet, stating that "[e]very line of this letter shows that they were and had been at war."[33]

Despite Evans's efforts to distance himself from the scandal, on July 18, 1865, he received the following letter from the secretary of state in Washington:

> *To John Evans, Esquire, Governor of the Territory of Colorado, Denver City.*
>
> *Sir; I am directed by the President to inform you that your resignation of the office of Governor of Colorado Territory would be acceptable.*
> *Circumstances connected with the public interest make it desirable that the resignation should reach here without delay. I am, Sir, Your obedient servant, William H. Seward.*[34]

His political career in ruins, Evans devoted himself to bringing the railroad to Colorado. In 1870, a new line opened between Denver and Cheyenne. What had once been an arduous overland trip by stage or wagon to Denver was now a smooth train ride—a change that transformed every aspect of life in the Colorado Territory.

After a long and successful career as a railroad financier, John Evans died on July 2, 1897. He is buried at Riverside Cemetery in Denver. The town of Evans, Colorado, and the 14,240-foot Mount Evans in Colorado's front range are named after him.

CAPTAIN SILAS SOULE

On New Year's Day 1865, Captain Silas S. Soule (pronounced "sole") and his men walked their horses along a bend in Big Sandy Creek, also known as Sand Creek, counting Arapaho and Cheyenne bodies. Most of the corpses, or what was left of them, were women and children. They had lain in the winter grass for over a month. By then, the work of the elements, wolves, coyotes and the hundred or so dogs living in the former camp had disguised the mutilations, but Soule wrote to his mother a few days later that all had been scalped. He did not mention the other things that had been done to the bodies. "I hope the authorities at Washington will investigate the killing of those Indians," he wrote. "I think they will be apt to hoist some of our high officials. I would not fire on the Indians with my Co and the Col said he would have me cashiered but he is out of the service before me and I think I stand better than he does in regard to his great Indian fight."[35]

Twenty-six-year-old Silas Soule was no stranger to violence and death. He was a hardened frontiersman and cavalry officer without qualms about killing warriors in battle. He was also handsome, funny and well loved by friends and family. He was known as a wag, a wit, a mischief, popular with ladies, fond of playacting and imitation—he specialized in Irish and German accents. He was highly skilled at the art of persuasion. The Denver and Central City papers reported frequently on his doings—a broad canvas of snippet reportage, ranging from fact to rumor to inexplicable remarks with the tone of inside jokes. Even during his tense Sand Creek testimony in front of John Chivington, Soule joked about a fellow officer being "excited" when Chivington objected to his use of the word "drunk."

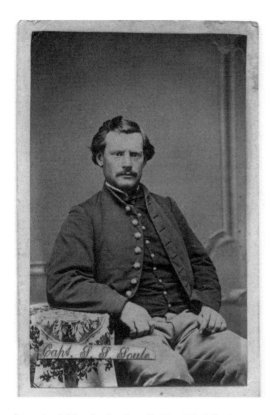

Portrait of Silas Soule. *Anne E. Hemphill Collection. Courtesy of Byron Strom.*

Soule came from extraordinary beginnings and had a gift for taking part in important historical events. He was born in Maine in an abolitionist family descended from George Soule, a passenger on the *Mayflower*. His father, Amasa Soule, was a cooper with a taste for politics. The Soule family's reading of *Uncle Tom's Cabin* inspired them to uproot and move to Kansas in the late 1850s. The race was on at the time between abolitionists and proslavery advocates to populate the fledgling frontier territory with voters. The Emigrant Aid Society of Massachusetts sponsored the relocation of half a dozen parties of abolitionists—some of them more suited to life on the frontier than others. The Soules were among the hardy founding families of Lawrence, Kansas, who stayed on.

Not surprisingly, Lawrence quickly became a major stop on the Underground Railroad. Soule and his father both worked as "conductors." According to Annie Soule, one of his two sisters, Silas worked with John Brown, who was later arrested and executed after the raid on Harpers Ferry.

"My brother, Silas, and Brown were close friends," Annie said in a 1929 interview.

> *Silas was out on many a foray with him. I recall well when Brown came to our cabin one night with thirteen slaves, men, women and children. He had run them away from Missouri. Brown left them with us. Father would always take in all the Negroes he could. Silas took the whole thirteen from our home eight miles to Mr. Grover's stone barn, two miles west of where*

the Haskell Indian school is now. The Negroes stayed there, hidden in the barn for several days, when a chance offered and they were taken still further toward freedom by another agent of the Underground.[36]

In January 1859, Dr. John Doy and his son, Charles, both of Lawrence, were escorting a group of free blacks north out of Kansas when they were captured. The would-be escapees were most certainly absorbed into the slave system, Charles was later released and Dr. Doy was taken to Missouri and tried twice. At the second trial, he was found guilty of abducting slaves and given a five-year prison term. A group of friends from Kansas, including Silas Soule, planned a rescue. In an affidavit, Doy describes how this rescue was initiated by a visit from a man later identified as Silas Soule:

Towards dark the outer door of the cell was opened, and a young man with a carpet bag…came to the grated door and informed me that he had recently seen my wife and son, that they were well, and hoped to see me within two weeks. He was quite curious about the jail, looking around a good deal, and as he stood with his back close to the grated door talking with the jailer, whose attention he directed to some means of ventilation outside, I, expecting something, saw a small slip of paper in the hand which he held behind him, and took it…

After the outer door was again closed…I read from it aloud: "Be ready at midnight."[37]

Midnight brought with it a storm and an arrested horse thief, escorted into the cell by two men. As soon as the jailer opened the cell door, the "horse thief" and his "captors" announced they had come to rescue Dr. Doy. They held a gun on Doy's jailer, headed out with their prize and ran on foot to the Missouri River, where several boats waited to spirit them across the heavy current back to the relative safety of Kansas. This rescue group soon became known throughout the region as the Jayhawker Ten.

After the Doy affair, Soule headed east to help rescue his old friend, John Brown, who had been captured at Harpers Ferry and was due to be hanged. Soule reportedly visited Brown in jail, but the rescue attempt was aborted, due either to snow or to Brown's refusal to participate. After Brown was hanged, Soule was involved in another plot to rescue two men from Brown's group, but that plan was also abandoned.

During his travels, Soule met and befriended Walt Whitman in Boston, along with men from the "Black String Society," a secret abolitionist group whose members identified each other by wearing black ribbons around their

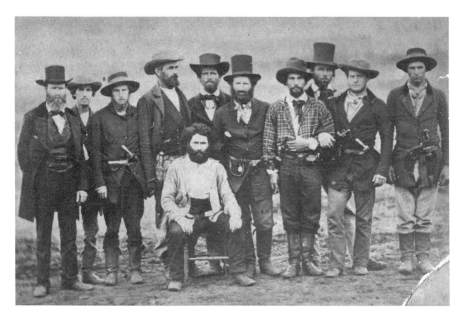

The Jayhawker Ten. John Doy is seated; Silas Soule is second from right. *Anne E. Hemphill Collection. Courtesy of Byron Strom.*

necks. These included the book publishers William Thayer and Charley Eldridge, who published the expanded third edition of Walt Whitman's *Leaves of Grass* and James Redpath's *Life of John Brown*.

When Soule returned to Kansas, he discovered that his brother, William, and many of their friends were heading west to join the Pikes Peak gold rush. In a move typical of the adventuresome, impulsive Silas, he took off for Pikes Peak. As he wrote to his new friends in Boston, "Now I must tell you something that will surprise you. When I arrived here I found a party waiting for me to go to pikes peak. My Brother and cousin were in the gang going with a quartz machine belonging to Solomon and Parker of Lawrence and there was no way but I must go."[38]

In Colorado, he spent a couple years mining and blacksmithing, ending up broke and restless in Central City. By the middle of 1861, he was already "getting D--n sick of this God forsaken place."[39]

When the Civil War started, he joined the First Regiment of Colorado Volunteers as a first lieutenant. The exuberant Soule wrote to Walt Whitman:

> *Perhaps you think I am writing very familiar for almost a stranger and writing to a distinguished Poet but I think I have made a sufficient apology*

when I tell you I have been in the Rocky Mountains for almost two years where every man is an old acquaintance if you never saw him before. When I left Boston I came to Kansas and from there out here among Grizzly bears, Indians, yankees and almost every species of man and beast that inhabit the globe. I have lived on venison and I have lived on bread. I have gone hungry for many a day and have had plenty to eat for many more. And for all the hard ships I have seen, it suits me. I like it. I enjoy myself hugely, and I think you would do the same.[40]

In March 1862, when an army of Confederates from Texas invaded New Mexico, the Colorado Cavalry was called in to help. Soule described the famous march of the First Colorado in a letter to Whitman:

As soon as we heard of the battle we made a forced march to the rescue. We marched a Reg of men 350 miles in 14 days. We marched 120 miles in three days and 80 miles in 24 hours. I think we made the biggest march on record. We understood that Sibley was making an attact [sic] on Fort Union. The word came to us about sundown after the men had marched 40 miles and had not had their supper and they threw their hats in the air and swore they would march 40 miles farther before they slept and they did. They started off singing the Star spangled banner, Red white and Blue and yankee doodle, so you can imagine what kind of material this Reg is composed of.[41]

In late March, Soule's Company K of the Colorado Cavalry fought in the Battle of Glorieta Pass. After Union troops destroyed their supply train, the Rebels headed back to Texas.

For much of the following year, Soule served as acting assistant adjutant general to Colonel John Chivington. Soule had written to Whitman about his affection for the "Fighting Parson": "Our Colonel Chivington was a methodist Preacher, 'Presiding' elder in Colorado. He is about six feet four inches high and built in proportion, a first rate fellow and liked by his Regament [sic]."[42] Four months before Sand Creek, he also wrote fondly of Chivington to his sister: "Our Col is a Methodist Preacher and whenever he sees me drinking, gambling, stealing or murdering he says he will write to Mother or my sister Annie so I have to go straight."[43]

That September, news reached Colorado of the August 21 attack on Lawrence, Kansas, by William Quantrill and three to four hundred proslavery "bushwhackers." At the time, Soule's brother William was

marshal of Lawrence, and their mother and two sisters also lived there. Soule's father, Amasa Soule, had died in 1860. During Quantrill's Raid on Lawrence, the bushwhackers destroyed a quarter of the houses and murdered over two hundred men and boys. They sacked and burned the Soule family home, but all family members escaped. On September 4, Soule wrote to his sister, Emily:

> *I sympathize with the sufferers at Lawrence and wish I was able to help them. Tell Mother to be brave and not fret over our loss. We will come out all right. Tell me in your next how much we lost there and where the house was and all the particulars. I will write more next time. I have no time now as the mail will close soon.*[44]

During 1864, he was stationed mainly in Fort Lyon but also wrote letters from Fort Garland; Conejos, Colorado; and Fort Fillmore in New Mexico. This was a period of increased skirmishes with bands of Cheyennes, Arapahos and Kiowas, and Soule was involved in several fruitless chases across the plains. In August, he wrote to his sister, Annie: "I am still at Fort Lyon and perhaps you had better direct your next here. I presume I shall be here some time yet. We have considerable trouble with the Indians. They would like to scalp us all. We have been chasing them for two weeks but only killed two. It is hard to get into a fight with them, they scatter so."[45]

During September, Soule accompanied Major Edward Wynkoop to Smoky Hill and the Camp Weld Council in Denver. After Camp Weld, he returned to Fort Lyon with Major Wynkoop and the chiefs. On October

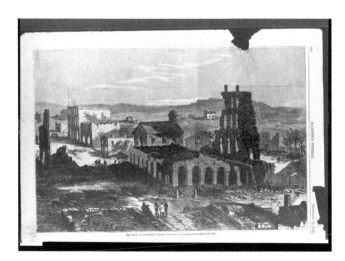

Sketch of Lawrence, Kansas, after attack by William Quantrill and Confederate raiders, September 19, 1863. *Library of Congress, Prints & Photographs Division.*

17, his relations with Colonel Chivington were still friendly, as he wrote to discuss issues about his company being mustered out, which was due to occur on January 26. He also mentioned the presence nearby of Arapaho chief Left Hand:

> *Colonel—*
>
> *I arrived here with Major Wynkoop on saturday. The command has not arrived yet but we expect them today. There is no news of importance here. There are about two hundred Indians camped fifteen miles from here awaiting the return of the chiefs. Left Hand is here with about twenty Indians. Today he says if all the rest go to war he will with his band lay down their arms and come in for protection, or fight even against his own tribe rather than take up arms against the whites.*[46]

Shortly after Major Wynkoop left Fort Lyon for Kansas, Soule was out on patrol when he met Colonel Chivington and the hundred days' men. During this unexpected encounter, Chivington quizzed Soule about nearby Indian camps. Soule reiterated that those camped at Sand Creek were the chiefs who had recently met with Chivington to talk peace, that they were considered prisoners and that they were waiting to hear from General Curtis about the next course of action. He later testified that "some one made answer that they wouldn't be prisoners after they got there."[47]

Soule soon realized what Chivington's intentions were, and he and other Fort Lyon officers tried to stop it. Soule later wrote to Ned Wynkoop:

> *As soon as I knew of their movement I was indignant as you would have been were you here and went to Cannon's room, where a number of officers of the 1st and 3rd were congregated and told them that any man who would take part in the murders, knowing the circumstances as we did, was a low lived cowardly son of a bitch. Capt. Y.J. Johnson and Lieut. Hardin went to camp and reported to Chiv, Downing and the whole outfit what I had said, and you can bet hell was to pay in camp.*[48]

Soule approached Major Anthony, who had previously assured Black Kettle and the others that he would maintain Wynkoop's policies until given further instructions. Anthony informed Soule that he had only been "acting friendly with them until he could get a force large enough to go out and kill all of them—'all the Indians,' or words to that effect."[49]

Soule later described what happened next:

I was warned by Major Anthony, Lieutenant Cramer, and some others not to go to the camp where Colonel Chivington was; that he had made threats against me for language I had used that day against Colonel Chivington's command going out to kill those Indians on Sand Creek.[50]

In a letter to General Curtis two weeks after the massacre, Chivington boasted that hundreds of warriors were killed and commended the "bravery and effectiveness" of his troops but added that he "cannot conclude this report without saying that the conduct of Capt. Silas S. Soule, Company D, First Cavalry of Colorado, was at least ill-advised, he saying that he thanked God that he had killed no Indians, and like expressions, proving him more in sympathy with those Indians than with the whites."[51]

In the days and weeks after the massacre, while Chivington and the hundred days' men returned to victory celebrations in Denver, Soule and the other Fort Lyon officers who had opposed the attack wrote letters to military and Congressional leaders. By January, most of the troops involved were mustered out of the cavalry, and in early February, Lieutenant Colonel Samuel Tappan began his investigation of the Sand Creek massacre.

Soule was the first witness called in for questioning. His testimony began on February 15 and lasted nearly a week. He declared that the people they attacked understood that "they were to be protected by the troops there until the messenger returned from General Curtis"[52] and that Major Anthony had told them to move their camp to Sand Creek.

After leaving Fort Lyon, Soule reenlisted and became the Denver provost marshal. In the months after the massacre, Soule told friends that several attempts had been made on his life. Despite these worries, on April 1, 1865, he married Hersa Coberly, a beautiful and clever young woman whose family ran a well-known stage stop called the Half Way House near today's Larkspur. Cavalry troops traveling between Camp Weld near Denver and the forts in southern Colorado often stopped at Coberly's. In his Sand Creek testimony, Lieutenant Joseph Cramer mentioned a visit to Coberly's after the Camp Weld Council. Silas had likely gotten to know the popular Hersa during such holdovers.

After the wedding, the couple made their home in Denver. On a quiet April night, less than a month after they married (and ten days after the assassination of President Lincoln), Silas and Hersa were returning home after an evening with friends. They heard gunshots out in the streets, so Silas escorted Hersa home and went back out to check on it. As he walked

down Lawrence Street approaching Fifteenth, a figure appeared out of the darkness and shot him in the face. At age twenty-six, the newlywed Silas Soule was dead.

Soule's friends were shocked and angered by his murder, and all of them believed that he had been assassinated at the behest of Chivington. He was buried with great honors, though undoubtedly Chivington's supporters stayed away. The killer was captured and brought back to Denver by a friend of Soule's, Lieutenant James Cannon, but the man escaped and Cannon died mysteriously.

That summer, Major and Mrs. Wynkoop, along with Samuel Tappan—all good friends of Silas Soule, probably as far back as their Kansas days—escorted his widow Hersa to Lawrence to stay with William Soule, Silas's brother. In August, Hersa described her grief to Silas's sister, Annie:

> *I like Will and Mary very very much but I don't think that Will is much like Silie, he is not so full of fun, but his eyes and hair are very much like My Silie's and I have no doubt but he is as good and I love him dearly but oh dear Annie no one can feel as I do, he was my future hope and sometime when I*

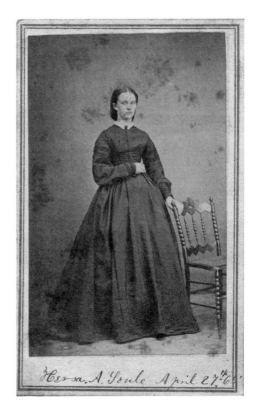

Hersa Coberly Soule, three days after the murder of her new husband. *Anne E. Hemphill Collection. Courtesy of Byron Strom.*

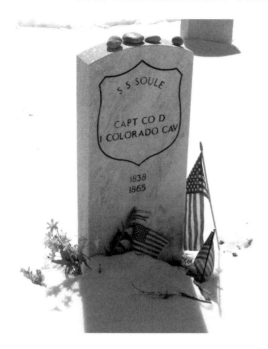

Military grave of Silas Soule at Riverside Cemetery in Denver. *Photo by Carol Turner.*

look at Will and see the very same eyes, I think oh, can it be, I want to throw my arms around his neck and say 'tis true you are with me yet my own dear Silie. The thought is almost maddening to me sometimes and I go to my room and stay for hours and read to get it off of my mind. Oh, I am afraid I shall make them unhappy. I would rather die than to. I think because it is fate to be unhappy it is not right that I should make others unhappy on my account.[53]

Five years later, Hersa was back in Denver, living with her brother, William Coberly. She later married a Boulder miner, Alfred Lea, with whom she had several children. Their son, Homer Lea, grew up to become a noted author of political books, an advisor to the Chinese leader Sun Yat-sen and a famous general in the Chinese army. Hersa Lea died in 1879 and is buried at Riverside Cemetery in Denver.

Silas Soule is buried in the Civil War section of Riverside. Every year on the anniversary of the Sand Creek massacre, members of the Cheyenne and Arapaho nations hold a Healing Run ceremony. Youngsters run from the Sand Creek site up to Denver, where they honor Silas Soule and Joseph Cramer at Soule's grave. They then march to the capitol, where they read aloud the letters written to Wynkoop by Soule and Cramer, telling the world what really happened.

CHIEF ONE EYE

Medicine man, charismatic speaker and loyal friend, Chief One Eye of the Cheyennes offered his life to make peace. Also known as Ochinee or Lone Bear, he lost an eye as a younger man while protecting the famous frontiersman William Bent from a Kiowa with a knife. Known as a medicine man among the Cheyennes, he also treated the entire Bent family over the years. William Bent told his son, George, that One Eye had saved his life again when he was gravely ill with a throat infection. One Eye devised a tool consisting of six strands of sinew. He threaded each strand with pea-sized sandburs lubricated with marrow grease. He bunched this into a ball and used a stick to push it down into Bent's throat. When the medicine man slowly pulled the sinew strings out, the putrid material dislodged. After One Eye repeated this procedure several times, Bent was able to swallow soup, and a few days later he was sitting up and talking.[54]

One Eye's family often pitched their lodges outside of Bent's Fort and remained for long periods of time. William Bent's daughter, Mary, was the best friend of One Eye's daughter, Amache, the two girls having grown up together around the fort.

Like Left Hand, One Eye's family was connected by marriage with the whites. In 1861, fifteen-year-old Amache Ochinee married an ambitious young man named John Prowers in an elaborate Cheyenne ceremony. Prowers had worked for Bent since the age of eighteen as a store clerk at Bent's Fort and as a captain of freight wagons. After they married, John and Amache lived at the old Bent's Fort, where they managed a stage station. Prowers later began running cattle and was one of the first big cattlemen in the region.

Cheyenne encampment, 1867–74. *Photo by William Soule. Yale Collection of Western Americana, Beinecke Rare Book and Manuscript Library.*

One Eye's critical role in the drama of Sand Creek began in late August 1864, when the Cheyenne and Arapaho chiefs received a letter from William Bent, urging them to try to make peace. Relations at that time between the whites and the tribes were tense. Since the shooting of Chief Lean Bear earlier that spring, Indian attacks had become more frequent. The stage between Denver and Kansas wasn't running because of fear of attacks, and the vicious raids on a wagon train in Nebraska and the Eubanks homestead in Kansas had just taken place in early August.

Governor Evans had sent out his first proclamation "To the Friendly Indians of the Plains" on June 27. The chiefs did not see it until late August, when they received the note from Bent. By then, Evans had already lost patience and had called on citizens to form a militia. Whether the chiefs knew about this isn't clear, but they responded to the first, friendlier, proclamation with a letter to Indian Agent Colley and Fort Lyon commander Edward Wynkoop.

Left Hand's brother Neva tried to take the letter to Fort Lyon but was chased away by troops. One Eye volunteered to try. His daughter was married to John Prowers, who was a prominent cattleman by then, and One Eye knew many of the officers at the fort. All agreed that he had a chance at getting into the fort without being killed, so he set out with his wife and another Cheyenne named Eagle Head.

This trio bearing the letter was intercepted on September 4 by Lieutenant George Hawkins. They approached the lieutenant and his party with their hands raised, waving sheets of paper. Although Hawkins was under orders to shoot Indians on sight, he chose not to. Instead, he took them back to Fort Lyon as prisoners.

With the ubiquitous John Smith translating, an exasperated Wynkoop told One Eye that he was lucky to be alive. In his autobiography, Wynkoop paraphrased One Eye's response:

> There was a time when the young men of my nation could leave their lodges containing wives and children, and go off to hunt the Buffaloe and the Antelope, when returning from the chase would find their families safe, happy, and contented; that time has passed, our white Brothers have made war upon us, have struck us, and we have struck them in return; they are many and we are few, they have arms and ammunition and cannon, while we have but Bows, Arrows and Spears...
>
> I am young no longer, I have been a Warrior, I have not been afraid to die when I was young, why should I be when I am old, therefore the Great Spirit whispered to me and said: "You must try and save your people" and I said to the Council of our head chiefs; give me true news, such as is written to carry to the Chief at the Fort, and I am here.[55]

Wynkoop goes on to describe his own reaction:

> I was bewildered with an exhibition of such patriotism on the part of two savages, and felt myself in the presence of superior beings; and these were the representatives of a race that I had heretofore looked upon without exception as being cruel, treacherous, and blood-thirsty, without feeling or affection for friend or kindred.[56]

After that fateful meeting between the two on a September day at Fort Lyon, Edward Wynkoop spent the rest of his life advocating for the tribes.

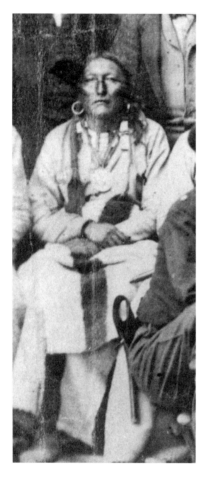

Bull Bear, chief of the Cheyenne Dog Soldiers. *Denver Public Library.*

During this meeting, One Eye persuaded Wynkoop to risk his life and the lives of his men to travel over one hundred miles to a large camp of Arapahos and Cheyennes at Smoky Hill in Kansas, where they would talk peace. One Eye stated that Black Kettle and the other chiefs had traded for the white hostages who had been taken in Nebraska and Kansas and that they would turn them over to Wynkoop.

One Eye and his group became Wynkoop's prisoners as they journeyed to Smoky Hill—a camp of nearly two thousand Arapahos and Cheyennes. The troops became alarmed when they arrived and realized that they were outnumbered by more than fifteen to one, but as Wynkoop explained, "I had so much confidence in the assurances of One-Eye" that he continued on.

During the Smoky Hill Council, the first to speak was Bull Bear, the chief of a fierce Cheyenne warrior society called Dog Soldiers. Bull Bear spoke angrily of his brother, the peaceful Lean Bear, who had visited Washington, D.C., that spring and who was shot by soldiers as he approached them to talk.

When Bull Bear finished, One Eye rose and berated him. He pointed out that Wynkoop had traveled to Smoky Hill in good faith and at great risk to himself. He said that he, One Eye, had "offered himself to Major Wynkoop as a pledge of their good faith, so that if the Indians did not act in good faith his life should be forfeited, as he did not wish to live when Cheyennes broke their word; that he was ashamed to hear such talk in the council as that uttered by Bull Bear."[57]

One Eye went on to offer Bull Bear his best stock if he would say no more in council. Bull Bear accepted the proposition, took two of One Eye's best horses and "had no more to say."[58]

Although One Eye did not attend the Camp Weld Council, he was present with Black Kettle's band when they moved to Sand Creek that November. Major Anthony also hired him at $125 per month to report rumors of hostile activities, which he did more than once during the short period before the attack.

When Chivington arrived at Fort Lyon, one of his first actions was to send out a party to the John Prowers ranch and place all there under arrest. John Prowers later testified that he was "taken prisoner one Sunday evening, about sundown, by men of company E, first cavalry of Colorado, by orders of Colonel Chivington, and my men, seven in number, were all disarmed and not allowed to leave the house for two nights and a day and a half, during which time the horses and cattle scattered for miles."[59]

Prowers stated that no reason was given for this arrest, but he understood it was because he "had an Indian family. The colonel commanding thought I might communicate some news to the Indians encamped on Sand Creek."[60]

Witnesses reported that, during the massacre, One Eye helped his family escape, but then feeling responsible for bringing his band to the place and promising their safety, he returned. The soldiers killed One Eye and desecrated his body.

At the Treaty of Upper Arkansas, signed one year after Sand Creek, the government created an Oklahoma reservation for the Southern Cheyennes and Arapahos. The government also made reparations to survivors and their families by granting 640-acre parcels of land along the Arkansas River. Grant recipients included One Eye's daughter, Amache Ochinee Prowers, her mother (One Eye's wife) and two daughters of Amache. John Prowers ran cattle on these lands, and they eventually became wealthy and influential citizens of the area. Prowers County is named after the family. The notorious Camp Amache, used to imprison Japanese Americans during World War II, was named for Amache.

Amache outlived John Prowers, who died about 1880. She remarried another rancher named Dan Keesee and died in 1905 at age fifty-eight. It is said that, although Amache dressed and lived like a white woman, throughout her life she continued many Cheyenne customs and to her dying day refused to wear a corset.

COLONEL JOHN CHIVINGTON

Woodsman, itinerant preacher, abolitionist and commander, John Milton Chivington's story is a tale of enormous ego and ambition, of a thirst for glory and of secret schemes to destroy his rivals. During his less than three years as Colorado's military commander, Colonel Chivington's political maneuvering created sworn enemies of all his peers, including Lieutenant Colonel Sam Tappan, Colonel John Slough and Colonel Jesse Leavenworth. For a time, he enjoyed extreme loyalty from some of his junior officers, including Major Wynkoop and Captain Soule, but that ended bitterly with his actions at Sand Creek.

Born on January 27, 1821, in Lebanon, Ohio, John Chivington spent his childhood in a small, crowded cabin. Four of the six Chivington children survived, and his father, Isaac Chivington, died when John was only five. At an early age, John helped his older brother Lewis manage the family farm, where they cut and sold timber. There were no regular schools, but the children attended classes whenever an itinerant teacher came through the area.

By 1840, Chivington was traveling often to Cincinnati, where he marketed and sold timber. There he met and married Martha Rollason, a slim, attractive girl who had grown up on a slaveholding Virginia plantation.

After marriage, Chivington became a carpenter as he and Martha started their family. At the same time, he began attending revival meetings and soon entered the church. He was ordained as a Methodist minister in 1844.

He spent the next dozen years preaching and traveling through Missouri, Illinois, Kansas, Nebraska and Ohio. At first, he supported his church's neutral stance on slavery. However, his position changed when a U.S. marshal

tried to arrest a member of his congregation as a runaway slave. Chivington hid the woman in his parsonage and refused to hand her over. This experience changed him, and he preached as a Free-Soiler from then on. In one incident, when a proslavery congregation in another town threatened to tar and feather him, he brought two pistols up to the pulpit along with his Bible.

In 1860, the firebrand Reverend Chivington arrived in Denver with plans to save the sinners who crowded the mining districts. There, he was appointed presiding elder in the First Methodist Episcopal Church. Chivington was a large man—over six feet tall and 250 pounds. By all accounts, one could hear his booming voice from afar. He was overbearing,

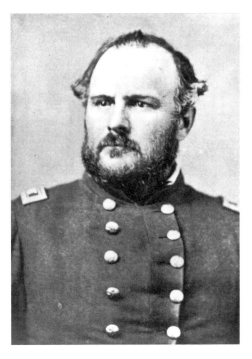

John Chivington, 1860–70. *Denver Public Library, Western History Collection, call number Z-128.*

accusatory, disapproving and sputtering with outrage at the sins he saw everywhere in the primitive frontier camps.

While the rest of the country was gearing up for civil war, Colorado Territory remained fixated on gold. When the war started in 1861, Governor William Gilpin raised the Colorado Cavalry. Many starving miners dropped their picks and shovels and joined up, although there wasn't much to do and they soon earned the disparaging nickname "Gilpin's Pet Lambs." Reverend Chivington quickly joined, turning down a commission as a parson, preferring to fight rather than pray.

The situation heated up in 1862 when, several hundred miles to the south, the Confederate "Walking Whiskey Keg," General Henry Sibley, and his Rebel forces from Texas invaded New Mexico with the reported goal of capturing the West and its gold fields for the Confederacy. In February 1862, the outnumbered Union forces under Colonel Edward Canby engaged the Texas Confederates at the bloody Battle of Valverde—a win for the Confederates. Canby requested reinforcements, and the First Colorado

was ordered to New Mexico. Their response was a legendary march—one thousand men crossing hundreds of miles of wilderness in record speed, under the leadership of Colonel John Slough and his second-in-command, the "Fighting Parson," Major John M. Chivington.

Soon after their arrival in New Mexico, Chivington and his "Pikes Peakers" engaged a force of Confederates at Apache Canyon, which began a three-day battle known as the Battle of Glorieta Pass. The fight at Apache Canyon brought the Union's first victory in what became known as the "Civil War of the West."

Two days later, Union forces engaged the Confederates once more at a place called Pigeon's Ranch. The battle itself was a tossup. However, that morning, Chivington and a contingent of five hundred men had headed into the mountains, intending to sneak around the enemy and attack from the flank. As luck would have it, a scout peered into a canyon and discovered the entire Confederate army supply train tucked away for safekeeping during the battle.

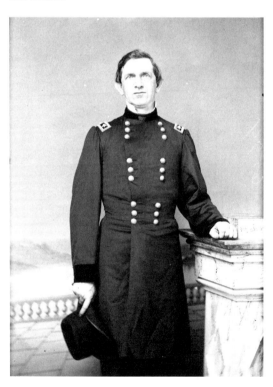

Edward R.S. Canby commanded Union forces in the "Civil War of the West." *Library of Congress, Prints & Photographs Division.*

Chivington's men used ropes and straps to lower themselves into the canyon, catching a hundred or so guards—mostly wounded soldiers—by surprise. They torched sixty to eighty wagons full of supplies— food, medicine, blankets, clothing, cooking gear and more. Chivington declared that he would execute the Confederate prisoners if the rest of the army returned. He ordered his men to slaughter the six or eight hundred horses and mules in the supply train—a grisly bloodbath that was repeated more than once throughout the history of the West. When the rest of the Rebels returned, they found nothing but burned wreckage and massacred animals.

Colonel Canby was both pleased at the success and annoyed that he had been overshadowed by Chivington. The battle for New Mexico was over. Without their supplies, the Texans were starving and demoralized, and in April of that year, they quietly left, with Canby's forces "herding" them along their way south.

The First Colorado spent the remainder of 1862 in New Mexico, during which time Commander Slough abruptly and mysteriously resigned his commission. The next in line would normally have been Lieutenant Colonel Samuel Tappan, but Tappan stepped aside and joined the others in urging that Chivington be given command.

These were glorious days for the members of the First Colorado—no longer dubbed "Gilpin's Pet Lambs." It was even more so for their hero, John Chivington. On August 1, 1862, the *Rocky Mountain News* ran a column signed by seventy-two prominent citizens of Denver inviting Chivington to give a talk about the New Mexico campaign. Newspaper reports lavished praise on him. He was fearless and gallant—an overnight sensation.

The year 1863 was a relatively quiet year in the young Colorado Territory. While Governor Evans worried about rumors of a tribal conspiracy to evict the whites, the Arapahos and Cheyennes battled disease and famine.

In Kansas, things were not so quiet. Incidents between settlers and tribes were frequent enough that Jesse H. Leavenworth, commander of Fort Larned, asked for additional help from Colorado, which had already sent troops. Chivington refused, insisting that Colorado's gold fields remained vulnerable to Rebel invasion from Texas. He won the argument.

In fact, rumors of Rebel invasion persisted in Colorado throughout the Civil War. During the summer of 1864, a gang of twenty or so white men attacked a wagon train east of Fort Lyon. They turned out to be Rebels turned outlaws, headed by a former Coloradan named Jim Reynolds. Ostensibly recruiting for the Confederacy, the Reynolds Gang busied themselves robbing and plundering settlements and wagon trains. In July, about half of the group was operating in the South Park area, staging brazen holdups while troops from the First Colorado chased after them. The cavalry eventually captured five of the men, including Jim Reynolds. They brought them back to Denver and proudly handed them over to the military commander, John Chivington. Chivington, who was running for Congress, quickly wrote to General Curtis, saying that he would try the prisoners in military court and bluntly asking permission to shoot them. Curtis was away, and his adjutant wrote back saying that he had no authority to approve executions.

Chivington ordered Captain T.G. Cree to escort the prisoners to Fort Lyon. At some point during this journey, all five prisoners were, according to S.E. Browne of the U.S. attorney's office, "butchered, and their bodies, with shackles on their legs, were left unburied on the plains."[61] In his outraged letter to General Curtis, Browne went on to say:

> Our people had no sympathy with these thieves, as they have none with other thieves, but they feel that our common manhood has been outraged, and demand that this foul murder shall not be sloughed over in quiet. When the news was first brought to Chivington of the death of these persons, and of the manner of their death, he sneeringly remarked to the bystanders: "I told the guard when they left that if they did not kill those fellows, I would play thunder with them." There is no doubt in the minds of our people that a most foul murder has been committed, and that, too, by the express order of Old Chivington.[62]

In September 1864, the hot issue was Colorado statehood. Governor John Evans was running for senator on the statehood platform, while Chivington ran for Congress. In the November elections, Chivington won his seat but lost it when the statehood issue was voted down, an event that must have deeply frustrated the ambitious Chivington.

In another blow to Chivington's power and authority, General Curtis had created the District of Upper Arkansas that July. He removed Fort Lyon from Chivington's command by placing it in the new district.

The greatest threat to Chivington, however, took shape in the person of General P.E. Connor. Fresh from a successful campaign against warring tribes in Utah, Connor was then assigned to protect the Overland Stage Route between Salt Lake City and Fort Kearny in Nebraska. He was planning a winter campaign against the raiding tribes along that route and wanted Chivington to "spare" him some troops and grain. Chivington quickly wired General Curtis, complaining that much of the Overland Route was within his own district.

It was no coincidence that on November 14, the day that Connor arrived in Denver to discuss his upcoming campaign, Chivington and the Colorado Third left the city and began their march south to Fort Lyon and Sand Creek.

By this time, less than a month remained of the one-hundred-day term for the Colorado Third. Aside from a minor skirmish in October, the troops had seen no action. Both Chivington and Evans faced great embarrassment if the "Bloodless Third" mustered out after sitting around for three months. Both men had great motivation to find some action for the regiment.

Ironically, Chivington's own military commission had already expired, but apparently his preoccupied superiors had failed to notice.

Upon leaving Denver, instead of heading eastward toward the Smoky Hills, where the Cheyenne Dog Soldiers were rumored to be, Chivington headed south for the Arkansas Valley, Fort Lyon and Sand Creek. It would be a simple matter to wipe out the unsuspecting bands who had camped there and to claim another glorious victory, which would secure for him his latest ambition—promotion to brigadier general.

After the attack at Sand Creek, Chivington spent a couple of weeks trying unsuccessfully to find Little Raven's band. When the one-hundred-day term expired, the soldiers headed back to Denver. On December 14, the *Rocky Mountain News* announced that "Col. Chivington, the 'old war horse,' will be here himself this evening, and that the Third Regiment are on the march here, to be mustered out. Many of their horses gave out so that the project of following up the Indians at the present was not deemed advisable."[63]

Denver citizens honored Chivington and the Third with celebrations and parades, and reports circulated of soldiers showing off their gruesome trophies from the mutilations in which they had engaged. However, the jubilant mood soon soured as other stories leaked out—from men like Soule, Cramer, Cannon, Tappan and others—detailing who had been killed and in what manner. And then the investigations began.

On January 12, 1865, about six weeks after the massacre, Major General Curtis wrote to General Henry Halleck:

> *Your despatch of yesterday, directing me to investigate Colonel Chivington's conduct towards the Indians, is received, and will be obeyed. Colonel Chivington has been relieved by Colonel Moonlight, and is probably out of the service.*[64]

Although Curtis replaced Chivington and condemned his conduct in this letter, he also stated that "the popular cry of settlers and soldiers on the frontier favors an indiscriminate slaughter, which is very difficult to restrain."[65] Although he must have read the letter Wynkoop brought to him from the Arkansas Valley settlers who approved of Wynkoop's policies, the tone and language Curtis used in this letter suggest an attitude similar to Chivington's. Chivington had other important supporters—Governor Evans, his attorney Major Jacob Downing and William N. Byers, editor of the *Rocky Mountain News*, whose family Chivington had reportedly rescued

during the big flood of Denver in April 1864. Although many more testified against him, about a dozen men spoke on his behalf. In his own defense, Chivington claimed that Major Anthony and Indian Agent Samuel Colley had told him that the Indians at Sand Creek were hostile—statements those men denied. Judging from letters and eyewitness testimony, Chivington knew exactly which groups were camped at Sand Creek.

After Sand Creek, Chivington never returned to preaching. Although the army did not prosecute him, the scandal destroyed his career. Other troubles followed. He lost his beloved son, Thomas, in a drowning accident in 1866, and Martha died a year later.

A broken Chivington left Colorado and spent the next eighteen years primarily running a freighting business in Nebraska, California and Ohio. He remarried in 1873, to a widow named Isabella Arnzen. In 1883, he was nominated for the Ohio state legislature, but he withdrew from the race when the Sand Creek story surfaced.

That same year, a group of Colorado pioneers invited Chivington to Denver for a speaking engagement. He may have been wary about returning, but to his great surprise and pleasure, he was once again treated like a hero. All of his old enemies were now dead or scattered. As a result of his warm reception, he and Isabella moved to Denver, where Chivington became deputy sheriff and coroner.

Alice Polk Hill, Colorado's first poet laureate and the author of an 1884 history called *Tales of the Colorado Pioneers*, includes the entirety of his 1883 speech in her book and paints Chivington in a flattering light. Her account of the one hundred days' men refers to "prancing steeds" and a "fine body of men." The massacre, she writes, "brought peace and quiet to the terror-stricken people of Colorado, by crippling the power of the most numerous and hostile tribe of the plains, and men resumed their struggle for daily bread without fear of the savage."[66]

For the time being anyway, Chivington was once more a hero.

Chivington died on October 4, 1892, at the age of seventy-one and is buried at Fairmount Cemetery in Denver. Neither Chivington nor any other officer involved in the Sand Creek massacre was ever charged with any wrongdoing.

LIEUTENANT
JOSEPH CRAMER

Joseph Cramer was born in 1838 in New York. He was one of tens of thousands of men who came west within a short period of time, hoping to find gold. When he arrived in Colorado, he headed into the mountains to the Central City area, where John H. Gregory's gold discovery had created the legend of the "richest square mile on earth."

Like most others, Cramer found more hardship than riches. Hard rock mining involved drilling holes into solid rock, blasting with black powder, mucking out the rubble and scaling away unstable rock slabs—much of which must be done inside a dark, poorly ventilated tunnel. Despite the many mills, general stores, saloons and "houses of ill fame" that appeared almost overnight in Gilpin County, most gold seekers lived in extremely primitive conditions. Cramer's friend, Silas Soule, referred to his own accommodations as a "dirt den."[67]

The 1860 census shows Cramer as a twenty-three-year-old living in Nevada Gulch, one of the early mining camps near Mountain City (today's Central City). In November 1861, a fire swept through and burned all night, destroying "all the improvements in Nevada Gulch, including Nevada City."[68]

By then, Cramer and many others had already forsaken the mining life and enlisted in the First Colorado Cavalry. In April of that year, the Civil War had started, and recruiting for the cavalry began in August. Many discouraged miners jumped at the chance for a steady income, although payday in "Gilpin's Pet Lambs" turned out to be sporadic at best.

Cramer was an understated figure—not flamboyant like Wynkoop or Soule. Gossip items about him did not show up in the papers as they did for the other two. However, his stand against Chivington was equally bold and

Central City, the "richest square mile on earth," 1869–79. From the *Beauties of the Rocky Mountains* series. *Library of Congress, Prints & Photographs Division.*

personally risky. Stationed at Fort Lyon under Major Wynkoop and then Major Anthony, he played a big role in Wynkoop's efforts to forge peace with the tribes. His testimony after Sand Creek was extraordinarily detailed and reliable. Almost everything he said was corroborated by other witnesses. Like Soule, Cramer was ordered to accompany Chivington to Sand Creek, but he told his men not to shoot during the massacre. And like Soule, he wrote a scathing letter to Wynkoop afterward, providing horrific and shocking details of what had happened.

In the weeks before Wynkoop's meeting with One Eye, in the middle of August 1864, Cramer engaged in a skirmish with some Arapahos who had

Mine shaft on Quartz Hill near Central City, 1869–79. From the *Beauties of the Rocky Mountains* series. *Library of Congress, Prints & Photographs Division.*

approached Fort Lyon. Chivington had ordered his officers to shoot Indians on sight. When a scout spotted the band, Wynkoop sent Lieutenant Cramer and Lieutenant Horace Baldwin out with a squad of fifteen soldiers each. Cramer soon spotted the Arapahos and pursued them for nearly twenty miles. At a point when most of Cramer's men were far behind, the band turned to fight. They engaged in a running skirmish that went on for four miles before the Arapahos rode off.

Cramer discovered later that the band was Left Hand's brother, Neva, trying to deliver the "peace" letter from Black Kettle. Neva apparently told Cramer that they had returned shortly after the running skirmish. A rainstorm had started, and the soldiers were vulnerable, watering their horses, but Neva would not allow his men to attack. Cramer testified that "Neva thought he could kill us all, but did not wish to fight, as he was sent out on a peace mission."[69]

At some point during that period, perhaps during the chase with Neva, Cramer suffered a riding accident in which his horse stumbled in a hole or a ditch and threw him. According to his military pension records, the fall injured his kidney, and he was laid up for a number of days.

Despite his injuries, Cramer accompanied Wynkoop, Soule and the others to the Smoky Hill Council that September and was present for most of the talks. At one point during the discussions, Cramer got word that trouble was brewing outside the council tent. The talks were being held in the soldiers' camp, and Wynkoop had left instructions not to let any additional Indians near. However, a number of Arapaho and Cheyenne men arrived and were nosing around. One small group was particularly interested in the mountain howitzers Wynkoop had brought. Before long, a shoving match erupted, and the lieutenant in charge, Lieutenant Hardin—whom Silas Soule later described as "excited" (drunk)—hastily called his men into formation, which escalated the tension. Fortunately, the coolheaded Cramer arrived and dismissed the men, telling them to back off and scatter about the camp in casual groups. A quick word to Black Kettle then took care of the problem.

Cramer later took charge of the cavalry escort that brought the chiefs to Denver for the Camp Weld Council. Although no known pictures of him exist, Cramer's wife later described him as tall and thin. Some historians have speculated that Cramer could be the gangly looking soldier standing far right in the Camp Weld group portrait.

Two months later, after Anthony replaced Wynkoop at Fort Lyon, Joseph Cramer was present during a critical meeting between Anthony and Black Kettle. He later testified:

> [Black Kettle] *was afraid that the soldiers from Denver and the east might come across some of his young men while hunting and kill them, and then he would be unable to restrain his men. Major Anthony told them that they would be perfectly safe.*[70]

Cramer's most important role in the drama was still to come, however. When John Chivington arrived that late November with the hundred days' men, Cramer was one of those most vocal in opposing the attack. He later described his conversation with Anthony:

> *I stated to him that I was perfectly willing to obey orders, but that I did it under protest, but I believed that he directly, and all officers who accompanied Major Wynkoop to the Smoky Hill indirectly, would perjure themselves both as officers and men; that I believed it to be murder to go out and kill those Indians, as I felt that Major Wynkoop's command owed their lives to this same band of Indians…*

I told him that I thought that Black Kettle and his tribe had acted in good faith; that they had saved the lives of one hundred and twenty of our men and the settlers in the Arkansas valley, and that he with his tribe could be of use to us to fight the other Indians, and that he (Black Kettle) was willing to do so. He (Anthony) stated that Black Kettle would not be killed; that it was a promise given by Colonel Chivington or an understanding between himself and Colonel Chivington that Black Kettle and his friends should be spared; that the object of the expedition was to surround the camp and take the stolen stock and kill the Indians that had been committing the depredations during the last spring and summer.[71]

Cramer, like Soule and the other protesting officers, was then ordered to accompany Chivington to Sand Creek. He later described what happened next in a devastating letter to Major Wynkoop:

Ft. Lyon, C.T., December 19, 1864

Dear Major:
This is the first opportunity I have had of writing you since the great Indian Massacre, and for a start, I will acknowledge I am ashamed to own I was in it with my Co. Col. Chivington came down here with the gallant third known as Chivington Brigade, like a thief in the dark throwing his Scouts around the Post, with instructions to let no one out, without his orders, not even the Commander of the Post, and for the shame, our Commanding Officer submitted...

Marched all night up Sand, to the big bend in Sanday, about 15 or 20 miles, above where we crossed on our trip to Smoky Hill and came on to Black Kettles village of 103 lodges, containing not over 500 all told, 350 of which were women and children. Three days previous to our going out, Major Anthony gave John Smith, Lowderbuck of Co. "G" and a government driver permission to go out there and trade with them, and they were in the village when the fight came off. John Smith came out holding up his hands and running towards us, when he was shot at by several, and the word was passed along to shoot him. He then turned back, and went to his tent and got behind some Robes, and escaped unhurt. Lowderbuck came out with a white flag, and was served the same as John Smith, the driver the same. Well I got so mad I swore I would not burn powder, and I did not. Capt. Soule the same. It is no use for me to try to tell you how the fight was managed, only that I think the Officer in Command should be hung, and I know when the truth is known it will cashier him.

We lost 40 men wounded, and 10 killed. Not over 250 Indians mostly women and children, and I think not over 200 were killed, and not over 75 bucks. With proper management they could all have been killed and not lost over 10 men. After the fight there was a sight I hope I may never see again.

Bucks, women, and children were scalped, fingers cut off to get the rings on them, and this as much with Officers as men, and one of those Officers a Major, and a Lt. Col. cut off Ears, of all he came across, a squaw ripped open and a child taken from her, little children shot, while begging for their lives (and all the indignities shown their bodies that was ever heard of) (women shot while on their knees, with their arms around soldiers a begging for their lives,) things that Indians would be ashamed to do. To give you some little idea, squaws were known to kill their own children, and then themselves, rather than to have them taken prisoners. Most of the Indians yielded 4 or 5 scalps. But enough! for I know you are disgusted already. Black Kettle, White Antelope, War Bonnet, Left Hand, Little Robe and several other chiefs were killed. Black Kettle said when he saw us coming, that he was glad, for it was Major Wynkoop coming to make peace. Left Hand stood with his hands folded across his breast, until he was shot saying, "Soldiers no hurt me—soldiers my friends." One Eye was killed; was in the employ of Gov't as spy; came into the Post a few days before, and reported about the Sioux, were going to break out at Learned, which proved true.

After all the pledges made by Major A- [Anthony] to these Indians and then take the course he did. I think as comments are necessary from me; only I will say he has a face for every man he talks. The action taken by Capt. Soule and myself were under protest. Col. A—was going to have Soule hung for saying they were all cowardly Sons of B-----s; if Soule did not take it back, but nary take aback with Soule. I told the Col. [Chivington] that I thought it murder to jump them friendly Indians. He says in reply; Damn any man or men who are in sympathy with them. Such men as you and Major Wynkoop better leave the U.S. Service, so you can judge what a nice time we had on the trip. I expect Col. C- and Downing will do all in their power to have Soule, Cossitt and I dismissed. Well, let them work for what they damn please, I ask no favors of them. If you are in Washington, for God's sake, Major, keep Chivington from being a Bri'g Genl. which he expects. I will send you the Denver Papers with this. Excuse this for I have been in much of a hurry.

Very Respectfully,
Your Well Wisher
(signed) Joe A. Cramer

(postscript)

John [Jack] Smith was taken prisoner and then murdered. One little child 3 months old was thrown in the feed box of a wagon and brought one days march, and there left on the ground to perish. Col. Tappan is after them for all that is out. I am making out a report of all from beginning to end, to send to Gen'l Slough, in hopes that he will have the thing investigated, and if you should see him, please speak to him about it, for fear that he has forgotten me. I shall write him nothing but what can be proven.

Major I am ashamed of this. I have it gloriously mixed up, but in hopes I can explain it all to you before long. I would have given my right arm had you been here, when they arrived.

Your family are all well.
(signed) Joe A. Cramer[72]

The day after the attack, Lieutenant Cramer was ordered to burn the village, which he did—an act that must have preyed on his conscience considering his feelings about the massacre. Silas Soule's similar letter to Wynkoop indicated that Cramer had also refused to shoot during the attack: "He [Chivington] said Downing will have me cashiered if possible. If they do I want you to help me. I think they will try the same for Cramer for he has shot his mouth off a good deal, and did not shoot his pistol off in the Massacre. Joe has behaved first rate during this whole affair."[73]

Cramer mustered out of the cavalry in November 1865. He immediately left Colorado—perhaps because his prospects there looked bleak, or perhaps because his friends Soule and Cannon were both now dead under questionable circumstances. He traveled to Iowa for a short visit with his parents and then moved on to Michigan. There, in December 1865, one year after the Sand Creek massacre, he married Henrietta S. "Hattie" Phelps. The newlyweds moved to Washington, D.C., for the winter, where Cramer tried to get a position as an Indian agent. Unsuccessful after a few months, he gave up, and the couple moved to Solomon, Kansas. There he worked as a clerk in a store. Hattie died in Solomon in August 1868, only three years after their marriage.

In 1869, Cramer was elected sheriff of Dickinson County, Kansas. He married Nancy Augusta Hunt in Lawrence, Kansas, on November 10, 1869. This marriage lasted only one year. After being bedridden for several months, Dickinson County sheriff Joseph A. Cramer died on December 26, 1870, at the age of thirty-three. His cause of death was listed as "injury to abdominal viscera."

The grave of Joseph Cramer at Prairie Mound Cemetery in Solomon, Kansas. *Photo by E. Malcolm Strom.*

During her decades-long struggle to convince authorities that she qualified for a military pension, his wife Augusta stated that when she met Joseph Cramer he looked thin and unhealthy. He was often in great pain, which he said originated from an injury sustained during his service at Fort Lyon. On behalf of Augusta, Ned Wynkoop gave a sworn affidavit describing how he believed Cramer had been injured:

> *That the said Joseph A. Cramer while in the line of his duty at or near Fort Lyon, then Territory of Colorado, did on or about the fifteenth day of September 1864 become disabled in the following manner* [unintelligible] *Said Lieut. Cramer went out with a detachment under his* [Major Wynkoop's] *orders from Fort Lyon Colorado to give chace* [sic] *to Indians. While in the pursuit, his horse fell throwing him heavily injuring him internally in his side from which he never recovered.*[74]

Cramer's chase with Neva's band took place on August 11, 1864, so this may have been the event to which Wynkoop referred in his statement, which he gave seventeen years later. In one of her depositions, Augusta stated, "It was thought at the time that the injury would cause a rupture. Soldier told me that there was no surgeon or ass't surgeon with the regiment when he was injured. Soldier told me that he went back to Fort Lyon, that is, he was taken back there by the men and was kept quiet at that place for some time."[75]

Joseph Cramer and his second wife Augusta are buried at Prairie Mound Cemetery in Solomon, Kansas. Like Silas Soule, he is honored every year by the Arapahos and Cheyennes for his role in exposing the Sand Creek massacre.

MAJOR SCOTT ANTHONY

A cousin of the famous women's suffrage leader Susan B. Anthony, Scott J. Anthony, was born in Cayuga County, New York, on January 22, 1830. He migrated west to Leavenworth, Kansas, in 1855. Perhaps because his father was a Quaker, Anthony became an abolitionist at a young age. He helped organize the Leavenworth Rangers, an armed group that patrolled the border to prevent proslavery Missourians from entering Kansas and voting.

Like many of those later involved in the drama of Sand Creek, he joined the exuberant exodus that drained the barely established Kansas towns and flooded the rough-and-tumble gold rush settlements in the Pikes Peak region. Arriving in 1860, he soon opened a store in California Gulch, today's Leadville. The following year, he joined the First Colorado Cavalry, of which he was appointed captain. After serving well during the New Mexico campaign, he was promoted to major.

In the fall of 1863, Anthony left Camp Weld near Denver to replace Samuel Tappan as commander of Fort Lyon. At the end of September, he led troops down the Arkansas River to Fort Larned in Kansas, stopping along the way to visit camps of Kiowas, Comanches, Apaches, Caddos and Arapahos. That winter, buffalo were scarce and many faced starvation. On September 24, 1863, Anthony wrote to his superiors about these visits. He noted that "[t]hey all express the utmost friendship for the whites; say they have been offered the war-pipe by the Sioux of the Platte, and all refused to smoke, except the Northern Cheyennes."[76] He mentioned that some had been "suffering terribly from disease and hunger," ending his letter on this revealing note:

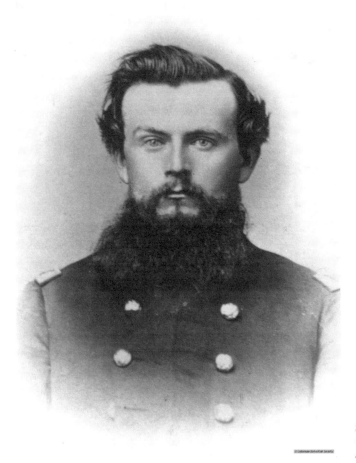

Scott Anthony.
*Colorado Historical
Society (Scan F2277).*

*The Indians are all very destitute this season, and the Government will be
compelled to subsist them to a great extent, or allow them to starve to death,
which would probably be much the easiest way of disposing of them.*[77]

On May 9, 1864, Major Wynkoop took command of Fort Lyon. In July,
General Samuel Curtis created the new District of the Upper Arkansas, with
headquarters at Fort Riley, Kansas. Fort Lyon fell under the new district.
In November, rumors circulated at Fort Riley and Denver about Wynkoop
handing out rations to hostile Indians and giving them the run of the fort.
When General Curtis found out about the trip to Camp Weld, he removed
Wynkoop from command and reassigned Anthony back to his old post.

Before leaving, Wynkoop arranged a meeting between Anthony and the Arapaho chiefs Little Raven and Left Hand, whose bands were camped near the fort. The chiefs were nervous about Anthony, telling their Cheyenne brothers that "things looked dark." They had referred to Wynkoop as the "Tall Chief." Now, they called his unwelcome replacement the "Red-Eyed Chief" because of Anthony's bloodshot eyes, a symptom of scurvy.

In Anthony's report about the meeting, he wrote that he asked them by what authority they had camped there:

> *They replied that they had always been on peaceable terms with the whites, had never desired any other than peace, and could not be induced to fight. That other tribes were at war, and therefore they had come into the vicinity of a post in order to show that they desired peace, and to be where the traveling public would not be frightened by them, or the Indians be harmed by travelers or soldiers on the road. I informed them that I could not permit any body of armed men to camp in the vicinity of the post, nor Indians to visit the post except as prisoners of war. They replied that they had but very few arms and but few horses, but were here to accept any terms that I proposed. I then told them that I should demand their arms and all stock they had in their possession which had ever belonged to white men.*
>
> *They at once accepted these terms.*[78]

Anthony then took up their arms, along with some mules and horses that he thought were stolen. He wrote that their stock and arms were poor and that they had very little ammunition. "In fact," he said, "these that are here could make but a feeble fight if they desired war. I have permitted them to remain encamped near the post unarmed as prisoners until your wishes can be heard in the matter."[79]

Within ten days, Black Kettle and his band came in, and Anthony had a similar exchange with them. He wrote to headquarters: "They professed friendship for the whites and say they never desired a war, and do not now."[80] He also mentioned that he had hired Chief One Eye to spy on hostile bands.

In his next letter to Curtis, written two weeks later on December 1, he described an "Indian expedition" that struck Sand Creek. In a detached tone, he provided the choreography of the attack. At the end of this long description, he said:

> *The camp proved to be of Cheyenne and Arapahoe Indians, and numbered about 1,100 persons, under the leadership of Black Kettle (head chief of*

the Cheyenne tribe). Black Kettle, and three other chiefs were killed. All the command fought well, and observed all orders given them.[81]

Aside from incorrectly claiming the death of Black Kettle (as several others did), this statement implied that he had no idea who was in the camp before the attack. His letter also left out the important detail that at least two of his officers—Soule and Cramer—blatantly disobeyed his orders and told their men not to fire. He makes no mention of the turmoil that took place among the officers at Fort Lyon before the expedition set out. He fails to admit that, with his permission, several people from Fort Lyon were visiting the camp at the time of the attack, including the interpreter John Smith, his wife and son, Jack, private David Louderback and a teamster, Watson Clark.

On the same day he wrote the previous letter, Anthony wrote to his brother Webster. This letter paints a different picture and includes a lie about the fate of John Smith's son, Jack, who was murdered after the battle by a soldier, apparently because he was half Cheyenne:

> *I will give particulars when I see you. We start for another band of red-skins, and shall fight differently next time. I never saw more bravery displayed by any set of people on the face of the earth than by those Indians. They would charge on a whole company singly, determined to kill some one before being killed themselves. We, of course, took no prisoners, except John Smith's son, and he was taken suddenly ill in the night, and died before morning.*[82]

In his next letter to Fort Riley written the following day, Anthony seems to have forgotten the image of a single Indian charging a whole company, claiming that "[t]his has certainly been the most bloody and hard-fought Indian battle that has ever occurred on these plains."[83]

By mid-December, Anthony began to change his tune in letters to his superiors. He wrote to General Curtis: "I now regret exceedingly that Colonel Chivington's command could not have pursued the Indians farther. We were not to exceed from two to three days' march from the main hostile Indian camp [on Smoky Hill], and, I think, with a force sufficient to have whipped them."[84]

He now describes the "desperation" of the Indians at Sand Creek, how 3 warriors charged 150 soldiers and how a woman was shot down as she attempted to escape but managed to cut the throats of her two small children before the soldiers could get them. He went on:

The massacre was a terrible one and such a one as each of the hostile tribes on the plains richly deserve. I think one such visitation to each hostile tribe would forever put an end to Indian war on the plains, and I regret exceedingly that this punishment could not have fallen upon some other band.[85]

During the investigations, Anthony's story shifted further. What he initially described as "the most bloody and hard-fought Indian battle that has ever occurred on these plains" had now become a massacre of women and children:

When I first came up with my command, the Indians, men, women, and children, were in a group together, and there was firing from our command upon them. The Indians attempted to escape, the women and children, and our artillery opened on them while they were running. Quite a party of Indians took position under the bank, in the bed of the creek, and returned fire upon us.[86]

He also described how a naked toddler was running through the sand, how three soldiers of Chivington's command dismounted from their horses and, one by one, shot at the child. The first two missed, but the third soldier finally shot the "little fellow" in the back.

Anthony's questioners during the hearings pressed him to explain what his orders were from his own headquarters in Kansas, but he could only state that they had not approved or disapproved Wynkoop's policies. During this testimony, he admitted that Left Hand and Black Kettle wanted to make peace.[87]

This testimony contradicted his earlier, feigned surprise that the camp "proved to be of Cheyenne and Arapahoe." He knew exactly who was in the camp and, in fact, had considerable dealings with them. He admitted that they "would send in" to the post frequently, describing these visits as "begging parties," but then went on to say that One Eye and Jack Smith both provided information to him about the movements of hostile Indians. Jack Smith had told him about a planned attack on settlements at Walnut Creek, information that he had forwarded to district headquarters. That attack did, in fact, take place.

Despite admitting to these ongoing friendly dealings, he still tried to rationalize his behavior:

I never made any offer to the Indians. It was the understanding that I was not in favor of peace with them. They so understood me, I suppose; at least I intended that they should. In fact, I often heard of it through their interpreters that they did not suppose we were friendly towards them.[88]

As Chivington tried to blame him, Anthony also went on the attack against Chivington. He claimed that he tried to save Jack Smith from being shot but that Chivington refused to do anything about it (testimony that revealed that he knew all along the true fate of the young man and that he had lied to his brother). He disputed Chivington's claim that a white woman's scalp was found in the camp, saying that Chivington invented this story when he got back to Denver. He said he "was with him for ten days after the fight, and never heard a word about a white woman's scalp being found in the camp."[89] In fact, Anthony vilified Chivington, declaring that he should be prosecuted. He denied any culpability in the massacre:

Question: Did you communicate to Colonel Chivington, when he came to Fort Lyon, the relations you had had with those Indians?
Answer: Yes, sir.
Question: Did you, under the circumstances, approve of this attack upon those Indians?
Answer: I did not.[90]

Throughout his testimony, Major Anthony presented a muddled, inconsistent story. One moment he claimed he was only waiting for reinforcements before attacking, and the next minute he described his many friendly dealings with them and insisted that it wasn't his policy to attack them. When pressed about why he followed Chivington's orders when he was not under his command, he gave the sweeping excuse that he'd been commanded to fight the Indians wherever he met them.

His explanations did not satisfy investigators, and they thoroughly castigated him in their report. The *Daily Mining Journal* also ran an editorial on January 5, 1865, asking similar questions about Anthony's actions:

Major Anthony was not stationed in the District of Colorado; he was not subject to the orders of Col. Chivington; therefore he joined the expedition of his own free will, and if it was, as he is reported to have said, "an unmitigated massacre of the only band of friendly Indians on the plains,"

why did he, knowing the facts, having been in command at Fort Lyon, join in the commission of such a dark deed?[91]

One possible conclusion is that Anthony did not particularly want to attack the people at Sand Creek but simply lacked the strength of character to stand up to the overbearing personality of John Chivington. His reasons went with him to the grave.

Anthony resigned from the cavalry in January 1865, about six weeks after the massacre. He moved to Denver and went to work for the railroad. In 1870, the federal census listed him as a clerk in the recorder's office, living in the household of his brother, Webster. During the next decade, he formed the abstracting company Anthony, Landon & Curry. In 1878, he married Lucy Stebbins, but in 1880 he was back living with Webster's family. It is unknown whether Lucy died or they divorced. About 1880, at the age of forty-nine, he married Frances Brown, a teacher fifteen years his junior. He and Frances had no children, and in later years they traveled extensively overseas. His obituary stated that he spent two and a half years on a tour of the globe. When he died on October 3, 1903, of "hay fever," he was a wealthy man and a prominent Denver pioneer.

CHIEF WHITE ANTELOPE

B orn about the turn of the century, White Antelope spent his early years as a headman of the Dog Soldiers, the most fearsome of the Cheyenne warrior clans. As such, White Antelope fought the Kiowas, Apaches and Comanches in the 1820s. He then negotiated peace with those tribes in 1840 at Two Buttes Creek in today's southeast Colorado.

In the 1830s and '40s, very few white men wandered into the uncharted wilderness that would become Colorado. In 1842, a group of venturesome traders arrived near the confluence of Cherry Creek and the Platte River—the spot at which others would found the city of Denver seventeen years later. There they encountered a Cheyenne village headed by Chief White Antelope. One of the men, Bill Hamilton, later wrote a book about his experiences. He described how they spoke in sign language with the Cheyenne, smoking together in White Antelope's lodge and feasting on "buffalo tongue, the choicest of meats, coffee, hardtack, and molasses."[92] During this meeting, Hamilton's group traded "powder, half-ounce balls, flints, beads, paint, blue and scarlet clothes, blankets, calico, and knives" for "all kinds of furs" from White Antelope's band.

The young Hamilton also befriended the chief's son, Swift Runner, who took him around the village introducing him to the leading men. Swift Runner invited Hamilton on a buffalo hunt the next day, during which Hamilton says that he "brought down four and received great praise from the Indians."[93] When Hamilton's group left, Swift Runner presented him with the pony he had ridden in the hunt.

Six years later, at a spot called Ash Hollow on the North Platte River in southwest Nebraska, Hamilton ran into White Antelope again. Today a

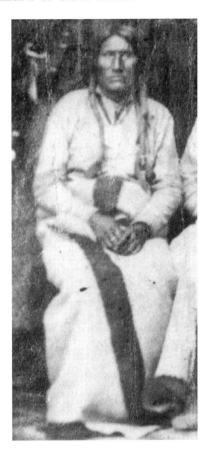

White Antelope, Cheyenne sub-chief. *Denver Public Library.*

historical park, Ash Hollow served as a pleasant stop along the Oregon Trail, offering fresh water, shade, rose, jasmine, grapevines and currant bushes. On this occasion, seventy-five friendly Cheyennes visited Hamilton's group. He recognized many of them from his visit to Cherry Creek in 1842, including White Antelope. They asked endless questions about where Hamilton's group had been, where they were going and who were the people in the group. He described White Antelope as "a noted chief and a proud and fine-looking warrior."[94]

Hamilton wrote about how the Cheyennes employed the buffalo as their means of sustenance and offered this assessment of the tribe he had come to admire:

> *The Cheyennes were and are to-day a proud and brave people. Their domestic habits were commendable and could be followed to advantage by*

Pioneers crossing the North Platte River. *Drawing by Daniel A. Jenks, 1859. Library of Congress, Prints & Photographs Division.*

Cheyenne warriors on horseback. *Edward S. Curtis Collection. Library of Congress, Prints & Photographs Division.*

many white families. To violate the marriage vow meant death or mutilation.
This is a rule which does not apply to all tribes. Meat is their principal
food, although berries of different kinds are collected in season, as well as
various roots. The kettle is on the tripod night and day. They use salt when
they can get it, and are very fond of molasses, sugar, coffee, and flour. They
are hospitable to those whom they respect, and the reverse to those for whom
they have contempt.[95]

A few years after Hamilton's encounter with White Antelope at Ash Hollow, nine tribes of the region, including the Cheyennes and Arapahos, signed the Treaty of Fort Laramie. In 1853, White Antelope joined a delegation of Southern Cheyenne chiefs who traveled to Washington, D.C., to meet with the president. As Chief Lean Bear would do ten years later, White Antelope left Washington with a medal and documents showing that he was a friendly Cheyenne who worked for peace with the whites.

The situation looked less promising in 1857, when White Antelope appeared at Bent's Fort complaining about an unwarranted attack on his band by soldiers. He referred to a battle between a group of Cheyennes and General Edwin Sumner earlier in the year. White Antelope expressed his frustration to William Bent that soldiers punished the Southern Cheyennes for depredations committed by the Northern Cheyennes—from the Cheyenne perspective a separate tribe.

In 1861, White Antelope helped negotiate the Treaty of Fort Wise, which drastically reduced the Cheyenne and Arapaho territory to a reservation around the Sand Creek area. In exchange, the government promised to build an Indian agency that would provide supplies and training so the tribes could transform into an agricultural society. The chiefs involved, including White Antelope and Black Kettle, signed the treaty but insisted that they needed agreement from their tribe. Very little came of this treaty. The tribes did not move onto the reservation, and the whites, preoccupied with the Civil War, made only desultory attempts to create the promised agency.

Three years later, White Antelope played an important role in the peace efforts by Black Kettle and Major Wynkoop. He spoke at length during the Camp Weld Council, which took place seven weeks before the Sand Creek massacre. The transcript documents a tense exchange between White Antelope and Governor John Evans. The governor began by saying that "if the Indians did not keep with the United States soldiers, or have an arrangement with them, they would all be treated as enemies."[96] White Antelope then spoke, with John Smith interpreting:

I understand every word you have said, and will hold on to it. I will give you an answer directly. The Cheyennes, all of them, have their eyes open this way, and they will hear what you say. He is proud to have seen the chief of all the whites in this country. He will tell his people. Ever since he went to Washington and received this medal, I have called all white men as my brothers. But other Indians have since been to Washington and got medals, and now the soldiers do not shake hands, but seek to kill me.[97]

A few minutes later, White Antelope attempted to explain to Evans how, from the Cheyenne perspective, the hostilities began with the unprovoked shooting of the revered Chief Lean Bear at the place called Fremont's Orchard. The exchange, translated by John Smith, demonstrates the communication problems that existed between the two sides and the difficulty of determining who was at fault in the skirmishes that took place that year:

Governor Evans: Who took the stock from Fremont's orchard and had the first fight with the soldiers this spring north of here?
White Antelope: Before answering this question, I would like for you to know that this was the beginning of the war, and I should like to know what it was for. A soldier fired first.
Governor Evans: The Indians had stolen about forty horses; the soldiers went to recover them, and the Indians fired a volley into their ranks.
White Antelope: This is all a mistake; they were coming down the Bijou, and found one horse and one mule. They returned one horse before they got to Geary's to a man, then went to Geary's expecting to turn the other one over to some one. They then heard that the soldiers and Indians were fighting somewhere down the Platte; then they took fright and all fled.[98]

After Camp Weld, the chiefs moved their bands to the vicinity of Fort Lyon and considered themselves under the protection of the military. Once Major Anthony replaced Wynkoop, White Antelope set up camp on Sand Creek with Black Kettle and the others, as Anthony had directed. White Antelope was in the camp, confident that his people were safe for the time being, when the soldiers attacked.

John Smith, who was also in the camp when the attack came, later said that White Antelope was the first one killed. In Joseph Cramer's account, he stated that "White Antelope ran towards our columns unarmed, and with both arms raised, but was killed."[99]

Cramer also stated that a soldier cut off White Antelope's fingers. Captain L. Wilson of the First Colorado Cavalry testified that a soldier cut off White Antelope's ears and that "the privates of White Antelope had been cut off to make a tobacco bag out of."[100] This testimony was corroborated by Robert Bent's statement: "I saw the body of White Antelope with the privates cut off, and I heard a soldier say he was going to make a tobacco-pouch out of them."[101]

Several witnesses told Wynkoop a similar story about White Antelope's death: "White Antelope folded his arms stoically and was shot down, refusing to leave the field, stating that it was the fault of Black Kettle, others, and himself that occasioned the massacre, and he would die."[102]

WILLIAM BENT

Aside from his good friend Kit Carson, William Bent was easily the most famous man in frontier Colorado. From 1833 to 1849, William, his brother Charles and Ceran St. Vrain ran the only privately held trading post on the Santa Fe Trail. Bent's Fort was the one oasis of "civilization" between the United States and Santa Fe. Everyone who came west during those years found refuge at Bent's Fort.

Born in St. Louis in 1809, William Bent followed his brother Charles to Colorado in the late 1820s. Together they established a profitable business, using oxen to haul goods back and forth between Santa Fe in what was then Mexico and St. Louis in the United States. They soon established Bent's Fort, from which they operated their lucrative trade.

When the United States invaded Mexico in 1846, Colonel Stephen Watts Kearny used Bent's Fort as his staging area for the Army of the West. The war was brief but profitable, as the United States claimed the vast territory now known as the American Southwest, plus California. Kearny appointed Charles Bent as governor of New Mexico. In 1847, rebellious locals assassinated Bent during the Taos Revolt.

During his nearly half-century in the region, William Bent developed an enduring bond with the Cheyenne nation. This friendship began in 1830 when he saved two Cheyennes from a party of Comanches. A grateful Chief Yellow Wolf (later killed at Sand Creek) became his trading partner, often setting up camp outside the fort.

In 1835, William Bent married Owl Woman, the beautiful daughter of White Thunder, the Cheyenne Arrow Keeper, who was the most important person in the tribe. Owl Woman taught Bent the Cheyenne language and

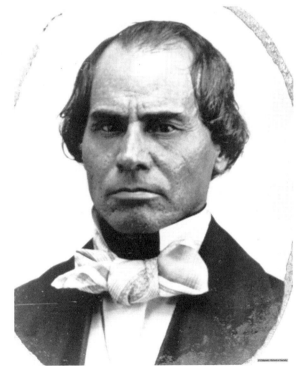

Above: Camp on the Arkansas River, April 23, 1859. *Drawing by Daniel A. Jenks, 1859. Library of Congress, Prints & Photographs Division.*

Right: William Bent. *Colorado Historical Society (Scan 10026616).*

bore him four children: Robert, Mary, George and Julia. By all accounts, Bent loved Owl Woman deeply and was devastated when she died in 1847. According to Cheyenne tradition, he took in her two sisters, Island and Yellow Woman. Yellow Woman bore him another son, Charley, but she did not get on well with William and did not live with the family. Island took over the role of mother to her sister's children.

During the invasion of Mexico, a young bride traveling to Santa Fe with her trader husband developed problems with her pregnancy. In June 1846, the wagon train of Susan Shelby Magoffin stopped at the fort and settled in while she tried to recuperate. Susan kept a vivid diary of the things she saw and heard. She described the outside of the fort as a place that "exactly fills my idea of an ancient castle,"[103] with high, thick walls made of adobe and a single entrance to the east. The fort had a water well inside the walls and twenty-five rooms, all with dirt floors that one sprinkled with water to keep the dust down. They had constructed sturdy log ceilings, with a heavy post in the center of the room. The fort had a kitchen, a dining room, a store, a blacksmith's shop, a barber and an icehouse, along with a number of bedchambers. Susan described the "greatest possible

Old Bent's Fort interior. *Drawing by Richard Turner.*

noise in the patio [yard]. The shoeing of horses, neighing, and braying of mules, the crying of children, the scolding and fighting of men, are all enough to turn my head."[104]

Susan, who turned nineteen during her stay, suffered a miscarriage at the fort. Afterward, she wrote in her diary about the pain and lethargy and of lying in the arms of "mi alma" (her husband):

> *My situation was very different from that of an Indian woman in the room below me. She gave birth to a fine healthy baby, about the same time, and in half an hour after she went to the River and bathed herself in it, and this she had continued each day since. Never could I have believed such a thing, if I had not been here, and mi alma's own eyes had not seen her coming from the River. And some gentleman here tells him, he has often seen them immediately after the birth of a child go to the water and break the ice to bathe themselves!*[105]

After the army billeted at Bent's Fort during the invasion of Mexico, Bent offered to sell it to them. The situation on the plains had changed, and business was bad. The army offered him an insultingly low price and—probably out of annoyance—Bent chose instead to destroy the fort in 1849.

The 1850s were a hard time for both the Bents and the Southern Cheyenne, whose ranks were decimated by starvation and epidemics. In 1853, William Bent began construction of another fort, called Bent's New Fort, located on the high bluffs overlooking the Arkansas at a place called Big Timbers. Times had changed, however, and his formerly thriving trade business never returned.

In the late 1850s, Bent served briefly as agent for the Cheyennes and Arapahos. As tensions rose during the gold rush, he often played intermediary between the two sides, delivering messages and trying to organize meetings. Bent and his half-Cheyenne children disagreed violently about the future of the tribe. Though his son Robert lived as a white man, both George and Charley felt more comfortable with the Cheyennes. William had long encouraged his Cheyenne friends to settle down and try to learn farming, while his sons increasingly felt that the Cheyenne should fight the white encroachment.

At the time of the attack on Sand Creek, three of William's five children were in the camp: George, Charley and Julia. In an ironic twist, John Chivington had forced Robert Bent to serve as guide for the soldiers, which understandably caused a deep rift among the Bent children.

Bent's New Fort, on a bluff overlooking the future site of Fort Lyon. *Drawing by Daniel A. Jenks, 1859. Library of Congress, Prints & Photographs Division.*

During the massacre, Silas Soule rescued twenty-year-old Charley and delivered him to Fort Lyon. Julia escaped with her future husband, Edmund Guerrier, the son of a French trader and Cheyenne woman. George also fled the camp but was shot in the hip as he made his escape.

Robert Bent later testified bitterly against Chivington:

> *When we came in sight of the camp I saw the American flag waving and heard Black Kettle tell the Indians to stand round the flag, and there they were huddled—men, women, and children. This was when we were within fifty yards of the Indians. I also saw a white flag raised. These flags were in so conspicuous a position that they must have been seen.*[106]

He described the slaughter and mutilation of women and children and recounted that he "heard Colonel Chivington say to the soldiers as they charged past him, 'Remember our wives and children murdered on the Platte and Arkansas.'"[107]

William Bent also testified against Chivington. He described his many efforts to make peace before the massacre. In particular, he recounted one

exchange that he'd had with Chivington, in which he told the latter how eagerly Black Kettle and White Antelope wanted to find a way to live in peace. Chivington replied that he was

> *not authorized to make peace, and that he was then on the war path—I think were the words he used. I then stated to him that there was great risk to run in keeping up war; that there were a great many government trains travelling to New Mexico and other points, also a great many citizens, and that I did not think there was sufficient force to protect the travel, and that the citizens and settlers of the country would have to suffer. He said the citizens would have to protect themselves. I then said no more to him.*[108]

Chivington's dismissal of the citizens' welfare proved to be prophetic. In January 1865, five weeks after Sand Creek, vengeful Cheyenne and Lakota warriors staged a series of attacks in northeastern Colorado. They killed twelve members of a wagon train near Valley Station and then plundered the station. They raided another small party, killing one and injuring the rest. They attacked and plundered the town of Julesburg. They lured soldiers out of nearby Fort Rankin and then attacked and killed fourteen of them. One of the leaders of these raids was a white man, identified as Charley Bent.

The Sand Creek massacre shattered William Bent's family. George and Charley Bent both joined the Cheyenne Dog Soldiers and fought in the subsequent war against the whites. Charley gained a reputation as a brutal and bloodthirsty killer and was reported to have tortured and mutilated at least one U.S. soldier. He died from fever in 1868 as a result of a gunshot wound. George survived the wars and eventually became an interpreter for Edward Wynkoop when Wynkoop became an Indian agent. George died in 1918, leaving behind many letters and interviews about his fascinating life. Julia and her husband Edmund had three children. Mary Bent, who was close friends with Amache, the daughter of Chief One Eye, died in 1878. Mary Bent claimed that Charley came to the Bent home one night with the intention of killing their father, but luckily William was not there.

William Bent married briefly again in 1867 to a "child bride," Adeline Harvey. When he died of pneumonia in 1869, his estate was in such a shambles that his children inherited almost nothing.[109] He is buried at the Las Animas Cemetery in Las Animas, Colorado. Bent County, Colorado, is named after him. History lovers have built a replica of Bent's Fort, which is now a major tourist attraction.

MAJOR JACOB DOWNING

In 1911, Mrs. Caroline Downing, widow of Jacob Downing, donated an object to the Colorado Historical Society. Identified as "Object E.1748.1," the donation is labeled as a "scalp taken from the head of an Indian warrior at the Battle of Sand Creek, Colorado, November 29, 1864."[110] Mrs. Downing presumably inherited the scalp from her husband, who accompanied Chivington to Sand Creek.

When she donated the scalp, Mrs. Downing must have been unaware that Jacob Downing had sworn in an affidavit taken during the Sand Creek investigations that "I saw no soldier scalping anybody but saw one or two bodies which had evidently been scalped."[111]

During his lifetime, Jacob Downing made little effort to hide his feelings about the tribes in the region. Completely like-minded with John Chivington on the topic, he still lied during the investigations. He hastened to remind them that he was "under Colonel Chivington when he went to Fort Lyon and when he made the attack at Sand Creek,"[112] implying that he was just following orders. Unlike Chivington, he managed to outmaneuver the scandal; afterward he returned to civilian life and enjoyed a profitable and successful career in Denver.

Jacob Downing was born on April 12, 1830, in Albany, New York. He studied law in Chicago and then traveled west to the primitive new settlement on Cherry Creek in the spring of 1859. Within a year, he had established a law practice and was elected judge of the municipal court.

At the outbreak of the Civil War, he recruited Company B of the First Colorado Cavalry, and Governor Gilpin appointed him captain. Downing fought in the Battle of Apache Canyon on March 26, 1862, and in the Battle

Jacob Downing. *Colorado Historical Society (Scan F43676).*

of Pigeon's Ranch two days later (together known as the Battle of Glorieta Pass). By all accounts, he served well and was afterward promoted to major.

Downing played a significant role in the Platte River campaign to "chastise" the Cheyennes in the troubled spring of 1864. He and his troops spent most of April and May in the region northeast of Denver, chasing bands of unidentified Indians up and down the South Platte.

His most notable battle was the fight at Cedar Canyon. He had received word that Cheyennes had taken over a ranch on the South Platte. They searched for the culprits along the river, encountering settlers in various states of panic. The settlers had heard stories and reported seeing a few lodges, but they had not witnessed any fighting.

Downing finally returned to camp, frustrated and anxious to find some band of Indians to punish. He wrote to Chivington:

> *I have just learned that there are a few lodges of Cheyennes at Gerrys. Though he* [Elbridge Gerry] *says they discountenance these transactions, I have, through Captain Sanborn, sent him word to notify these Cheyennes to leave immediately, as well as all others who may be on the river, as I intend punishing them for depredations committed by members of this tribe if found on the river. My object is to protect the immigration and get as many together as possible, when, if you think proper, a command can go to their village and compel them to surrender the depredators, or clean them out.*[113]

A week or so later, Downing received reports of a group of Cheyennes who had stolen some horses. Downing and his men set out in search of the thieves. When they came upon a deserted camp, which may or may not have been that of the horse thieves, they destroyed it. Soon afterward, they captured a lone man, whom they took prisoner. Downing wrote to Chivington:

> *Colonel: Since my last we have been busily engaged scouting, & c., endeavoring to ascertain the whereabouts of the enemy. Yesterday we took an Indian prisoner, whom I at first ordered shot, but upon learning from one of my men that he was half Sioux and had received his annuities from Government with the Sioux, I concluded to spare him if he would lead me to a Cheyenne camp or give me information of their whereabouts, which he has consented to do, and we are about starting in pursuit. Besides, all concurred that if I killed him it would involve us with the Sioux, which, as I understand, the policy is to avoid a war with them. If, though, I obeyed my own impulse, I would kill him. Should he attempt to escape will settle him.*[114]

The Sioux prisoner led them to a Cheyenne camp at Cedar Canyon, also called Cedar Bluffs; Downing and his forty men ran off the horses and attacked. Downing later stated that the canyon was "occupied by warriors with rifles."[115] He also stated that there were "women and children among the Indians, but, to my knowledge, none were killed."[116] The soldiers killed about twenty-five Cheyennes and wounded forty more.

Downing later explained this unprovoked attack: "I made my attack on the Indians from the fact that constant statements were made to me by the

settlers of the depredations committed by the indians on the Platte, and the statements of murders committed: and I regarded hostilities as existing between the whites and Cheyennes before I attacked them at Cedar Bluffs."[117]

Later, Black Kettle told his version of these events to Joseph Cramer and John Smith. According to Black Kettle, the village at Cedar Canyon consisted of "squaws, papooses, and old men" and that this group was unaware of any war going on between their group and the whites.[118]

After the attack, Downing wrote another letter to Chivington:

> *Colonel: Though I think we have punished them pretty severely in this affair, yet I believe now it is but the commencement of war with this tribe, which must result in exterminating them.*[119]

In November of that year, Downing accompanied Chivington on his ride down to Sand Creek. He would have been one of "the command of Colonel Chivington" at a dinner described by a witness from Fort Lyon named James Combs. Combs reported that Chivington and his officers were joking about Left Hand being in charge of the fort, about their planned attack, what scalps they were going to take and how they would arrange them.[120]

Downing later claimed in his sworn affidavit that he had "no knowledge of what occurred between the Indians and Major Wynkoop."[121] He stated that Major Anthony "urged an immediate attack on the Indians, stating that he would like to save out of the number a few who he believed to be good Indians; mentioning the names of One Eye, Black Kettle, and one other, stating that the rest ought all to be killed."[122]

Like Chivington, Downing testified that they had killed five or six hundred Indians—three times the actual number. He swore that he counted only "about twelve or fifteen women and a few children, who had been killed in the trenches."[123]

In this same testimony, for at least the second time on public record, Downing made no attempt to disguise his feelings about the Cheyennes and Arapahos: "I heard Colonel Chivington give no orders in regard to prisoners. I tried to take none myself, but killed all I could; and I think that was the general feeling in the command. I think and earnestly believe the Indians to be an obstacle to civilization, and should be exterminated."[124]

During the Sand Creek investigations, Downing served as John Chivington's lawyer. Local papers and many citizens of Denver supported the attack and resented the investigations and the comments being made back east about the behavior of the Colorado Third and its commander.

A notice in the *Rocky Mountain News* reported: "Major Downing got back by this morning's coach, from Fort Lyon, where he has been for some time past, on business pertaining to ye 'Military Commission', about Sand Creek affairs and such. The Major knows more in a minute than that whole investigating outfit!"[125]

After escaping any sort of censure, Downing mustered out of service in 1865 and returned to his law practice. In October 1865, he ran for supreme judge as part of the "Soldier's Sand Creek Vindication Ticket."[126] In 1867, Downing was elected probate judge for Arapahoe County.

Downing went on to build a successful and profitable career. He made numerous real estate transactions and developed considerable areas of the city. Downing Street in Denver is named after him.

He also purchased two thousand acres of land west of town and built fences and irrigation ditches, calling his ranch the Down Dale. He is credited with introducing alfalfa to Colorado. He grew fruit trees and sugar beets and raised livestock and poultry there. He brought the first quail and the first Herefords to the state, according to his obituary, and became well known for his thoroughbred Arabian horses, including a celebrated racehorse named Major Downing. Later, the Down Dale ranch, located east of Green Mountain, was sold and became the location of today's Federal Center.

In 1871, Downing returned to New York, where he married Caroline E. Rosecrans. The *Rocky Mountain News* noted this event: "Major Downing, another of the army of bachelors, has returned from the east with a wife. As with all the rest of them, marrying seems to agree with the major."[127]

For the rest of his life, Downing enjoyed the reputation as a great soldier. Newspapers during those years published wildly embellished stories about battles between the whites and the Indians. One earnest "historian" claimed that "[u]pwards of 250 [white] men, women, and children were massacred in the space of eight months," during the period just preceding the Sand Creek massacre.[128] The actual number of settlers killed in Colorado during that period is fewer than ten.

Jacob Downing died in 1907. His obituary appeared in newspapers across the state, in which he was referred to as a "noted Indian fighter." He is buried at Fairmount Cemetery in Denver.

LIEUTENANT
JAMES CANNON

James Cannon volunteered with the First Infantry regiment of New Mexico, a unit organized in 1863. He enlisted on January 1, 1864, only eleven months before Sand Creek. He probably served on garrison duty at Forts Union and Craig before being assigned to Fort Lyon in September. There, Cannon joined the other officers in signing a letter in support of Major Wynkoop's cooperative policies toward the Cheyennes and Arapahos. He was also present in the fort when Chivington arrived with the Colorado Third.

In his eloquent testimony after the massacre, he demonstrated a shrewd understanding of the political undertones of what was going on—that Chivington was apparently looking for easy glory before the one hundred days' men mustered out of service:

> *Major Anthony came to me on the 28th of November, and asked me if I was willing to go out as adjutant of the Fort Lyon battalion on an Indian expedition. I asked Major Anthony what the object was of this expedition. He told me that it was to be a thorough, vigorous Indian warfare. I told him if such was the case I had no objection to go; that I would do as much and go as far as any person; but that I was fearful that it was only of short duration, as the principal part of Colonel Chivington's command were one-hundred-days men, whose term of service had nearly expired; that I was fearful that all it would amount to was that they would go out there and jump into the band of Indians that we had coralled. He assured me again that it would be a thorough, vigorous warfare; that we would go on to the Smoky Hill and Republican. He then issued an order placing me on duty as Adjutant of the Fort Lyon battalion.*[129]

Mountain howitzer in front of ruins of Fort Union, New Mexico. *Library of Congress, Prints & Photographs Division, HABS NM-164-3.*

Cannon also gave shocking details about the soldiers' acts of depravity during and after the massacre. He said that when he returned to the camp the next day, "I did not see a body of man, or woman, or child, but what was scalped, and in many instances their bodies were mutilated in the most horrible manner—men, women and children's privates cut out. I heard one man say that he had cut a woman's private parts out and had them for exhibition on a stick."[130]

He corroborated testimony from several other witnesses about a baby a few months old who was tossed into the feedbox of a wagon and then left on the ground to die. He described how some soldiers had the private parts of women stretched over saddlebows and hats.

He stated that, to the best of his knowledge, Chivington was aware of these atrocities and took no measure to prevent them. In fact, Cannon testified that after the attack, Chivington told him that "[t]he fight was the most successful thing on record; that we had achieved a glorious victory."[131]

Four months after the Sand Creek massacre, James Cannon played another important role in the drama. On April 23, 1865, Cannon's friend, Denver provost marshal Silas Soule was assassinated on the streets of Denver. The shooter was wounded in the hand and left a trail of blood as he ran. Within moments, others arrived on the scene, but it was too late for Soule. They carried his body into a nearby building used as a headquarters for officers of the district.

When word got out in the morning, the curious crowded around the spot where Soule died. Patrols searched every house in Denver. Suspicion had already fallen on Charles W. Squires, who had appeared in a camp on Curtis Street the night before with a wounded hand, bragging that he had killed someone. With him was a man named Morrow, whose involvement was unclear. Both men then disappeared. Newspaper reports said at first

that Squires complained that Soule had previously confined him to the guardhouse and that this was a revenge killing. However, the *Daily Mining Journal* quickly questioned this theory:

> *Poor as it is (not one soldier in a million would think it cause of lasting resentment, much less an excuse for murder) it might be endured, but that two former attempts to accomplish the same purpose on Soule have been made within four months. On one occasion, as he was returning late at night from West Denver, five shots were fired at him by some concealed person, which shots came so near him as to leave no doubt of their intentions. Subsequently, he was both followed and headed by two or three men, whose movements, evidently in concert, finally alarmed him, and being alarmed, he beat a retreat to his headquarters and so escaped attack. Such are the facts as related to us by himself. All this might be passed over without suspicion of anything behind the scenes, did not rumor connect these occurrences most painfully with another event, which it seems certain parties are averse to having uncovered to the world.*
>
> *We allude to Sand Creek. Our readers are aware of the action of Wynkoop and Soule last Summer, in rescuing the White prisoners from the Indians and procuring a conference between them and the authorities at Denver. To be brief,* the Indians surrendered, and as prisoners of war, were attacked by Chivington.
>
> *…Well, an order for an investigation was procured, the commission met, and these assassin attacks commenced on Soule. The commission took some testimony in Denver and then went to Ft. Lyon for the same purpose. Soule was not molested while they were away. But within a week, the commission returned to Denver. And a soldier of another regiment than Soule's, whom many of our citizens will remember as an utterly insignificant individual, secretes himself behind a church in the night and shoots Soule dead, and gives as a pretext for the horrid deed, that "Soule had once caused him to be confined in the guard-house!"*
>
> *We leave the public to draw their own conclusions, referring them to the fate of Henderson at Camp Weld in 1862, and to the shooting of Reynolds and his guerrillas, last summer, "in an attempt to escape."*[132]

On Wednesday of that same week, Soule was buried. An inquest determined that he had been murdered. A newspaper notice on May 4 noted that Squires still had not been caught, and later notices indicated that he had been spotted near Fort Union in New Mexico.

In June, Squires was arrested in Las Vegas, New Mexico. Some accounts noted that Lieutenant James Cannon arrested him; others reported that two local men, hoping for a reward, had caught him and handed him over

to Cannon. A later newspaper report gave all the credit to Cannon for his "prompt, vigilant action," stating that Cannon had been in Las Vegas looking for Squires and left information about the fugitive there. The two New Mexico men later spotted Squires and sent for Cannon to come and make an arrest, which he did. Cannon then escorted Squires to jail at Fort Union.

A statement from Squires was leaked to the press. In it, he claimed that he'd been drinking with the man named Morrow, after which they went to a firing range to shoot. They then wandered back into town and sat in a doorway, at which point Soule came by and asked if they were soldiers. Squires said:

> *I had one pistol in my belt and one in my hand. I had it in my hand from the time I had been firing. I walked out into the street in front of Capt. Soule and saw him raise his pistol and point it in our direction. Morrow was behind me and a little to the right. As soon as I saw the pistol pointed, I raised my hand to speak to him, but I did not say anything because Capt. Soule fired so quick I had no chance. The ball from his pistol struck me in the hand on the knuckle of the third finger and going up my hand, came out on the underside of my wrist. Almost immediately Morrow fired and Capt. Soule fell. I stood a few minutes and looked on, and I saw that Morrow was gone. I went directly to the camp which was two or three hundred yards distant. When I got there, I found Morrow coming away.*[133]

Fortunately for Morrow, nobody believed Squires's story, and a pistol left at the scene was identified as belonging to Squires. People in the area said that they heard three shots—the first two in quick succession and a third after a brief interval. They stated that the second shot was noticeably faint compared to the others, which indicated that it was a very small pistol—probably a derringer. Due to the threats on his life, Soule carried a pair of pocket derringers with him at all times. From this evidence, the newspaper reported, "We deduce that Squires fired first and missed; Soule fired, probably through his pocket, the ball passing through Squires left fore-arm; Squires then introduced his pistol into Soule's face, as it were, and shot him dead."[134] Another witness said that Soule had not arrested Squires and did not even know him.

In mid-July, Cannon brought Squires back to Denver to stand trial by court-martial for the murder of Captain Silas Soule. The next event caused great shock and consternation to many in town: James D. Cannon was found dead in his hotel room at the Tremont House.

Rumors circulated wildly about how Cannon had died. Many speculated about the timing of his death only a few days after he brought in Soule's assassin.

Two doctors performed a postmortem exam and testified at the coroner's inquest. They said that the body showed no sign of convulsions or external injury but that the "brain and membranes were congested. A large amount of serum and blood, a gill [a quarter pint] or more, escaped on removing the skull cap. No evidence of other disease; but this congestion would be sufficient to cause death."[135]

The doctors did not state how he died but mentioned possibilities of poisoning, apoplexy, alcohol or morphine. A packet of morphine was found in Cannon's room.

The fact that a large amount of blood escaped when they opened his skull also suggests a possible closed-head injury caused by blunt force trauma. A sick woman in the room next to Cannon's at the Tremont testified that the night Cannon died she heard someone enter Cannon's room and lock the door. She later heard a maid deliver a towel, after which Cannon double-locked his door. The witness said that at 8:00 p.m. that same evening:

> *I was awakened by heavy groans in the adjoining room, and sounds as of rapping against the wall or head of the bed. Soon after the clerk came up with the boy and medicine, and I asked him who was sick in the next room; he said no one was sick—that that was Lieutenant Cannon's room. I told him someone was sick, and if I was well enough I would get up and see about it. I heard no more noise that night.*[136]

The inquest concluded that James Cannon's cause of death was "congestion of the brain."

In August, Squires was put on trial by court-martial, but the trial was postponed because the judge advocate had to leave town on other business. They were also awaiting the arrival of defense witnesses.

On October 9, Charles Squires escaped from the guardhouse. Two conflicting stories appeared in the papers describing his escape. In the first story, someone picked the padlock at the back door of the building and then used a chisel to remove Squires's shackles. In the other story, friends of Squires had complained about the cruelty of his shackles, so authorities removed them. After that, he simply walked away. In both stories, his guards were mysteriously absent at the time of the escape.

James D. Cannon was buried in Denver, and the mystery of his death was buried along with him. He left behind a wife, Helen. Charles Squires was never caught.

LIEUTENANT COLONEL SAMUEL F. TAPPAN

Samuel Forster Tappan was an intriguing mixture of adventurer and literary intellectual. Though his formal education was unremarkable, he read voraciously throughout his life. He wrote quotes in his diary from Homer, Shakespeare, Tennyson, de Tocqueville, Thomas Moore, William Blackstone, Macaulay and Emerich de Vattel. He also abandoned the comforts of home and family in New England, heading west to face a volatile and dangerous frontier in Kansas and Colorado. Amid these rough societies, Tappan repeatedly made decisions that demonstrated a mature and progressive nature that was rare for that time and place.

Born on July 29, 1831, in Manchester-by-the-Sea, Massachusetts, he came from a prominent family that included famous abolitionists Arthur Tappan and Lewis Tappan. As a young man, Samuel worked with his father making furniture and later in his uncle's store in Boston. In 1854, at the age of twenty-three, he traveled west with a group of abolitionists associated with the Emigrant Aid Society—the same group that sponsored the Soule family. Like the Soules, Tappan was among the founders of Lawrence, Kansas.

In Lawrence, Tappan became a journalist, writing about the "Bleeding Kansas" wars for the *New York Tribune* and the *Boston Atlas*. He was also a member of the Underground Railroad and was involved in the rescue of free state activist Jacob Branson, who had been arrested by a proslavery sheriff.

As a political activist, Tappan traveled throughout Kansas, speaking on behalf of the free state movement, which endeavored to align Kansas with the antislavery North. In the late 1850s, he participated in several constitutional conventions.

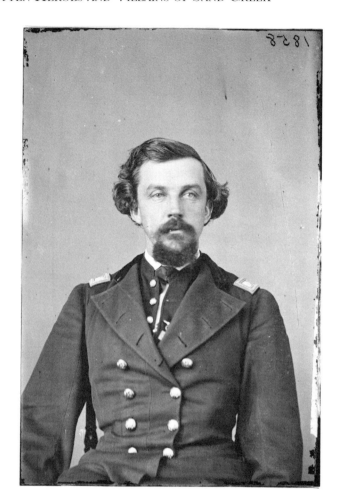

Samuel Tappan, 1860–70. *Library of Congress, Prints & Photographs Division.*

After six years in Kansas, Tappan joined the Pikes Peak gold rush in July 1860. October saw him already active in local Denver politics. As secretary pro tem of the Denver City Council, he helped create a code of laws for Denver, empowered fire wardens to inspect buildings and laid out plans for new streets and bridges. Several of his cousins—Lewis, George and William—also arrived in Denver and opened one of the first general stores, Tappan & Co.

When the Civil War began, Tappan enlisted as a captain and set about filling the ranks of the First Colorado Cavalry from among the demoralized miners in Gilpin County. Colorado had just become a territory in February, and unlike Kansas, it fell squarely into the Union camp. There were, however,

many Confederate sympathizers in Denver and the mining towns, and newspapers reported shots being fired at the soldiers. One saloon in town, the Criterion, was the center of much carousing and fighting. It was owned by a notorious gunman and Rebel sympathizer named Charles Harrison. Tappan was involved in at least one altercation with Harrison in which he leveraged the superior firepower of the new cavalry:

> *Another Attack on Our Volunteers.*
> *On Saturday night about eleven o'clock, while the guard were parading around their rendezvous on F street, several shots were fired upon them, wounding one in the ancle [sic] and cutting him through the ear. The firing was from the back of the Criterion Saloon, and Capt. Tappan immediately ordered his men out in squads to prevent any further incursions on his men from such dastardly attacks of the enemy. One squad was ordered to the Criterion. They planted the cannon in front of the building, and ordered the concertroom and saloon to be cleared. Capt. Tappan and Lieut. Logan placed themselves at the door, and demanded the arms from all parties not known to be friendly.*[137]

Tappan was first stationed at Camp Weld, where he trained the troops. He took command of three companies and moved to Fort Wise, which was renamed Fort Lyon in 1862. The remainder of the regiment stayed on at Camp Weld under Major John Chivington.

When the New Mexico campaign began, the now lieutenant colonel Tappan took command of companies F and S, as second in charge of the entire First Colorado under Colonel John P. Slough. Tappan and his men fought at the Battle of Glorieta Pass, where Tappan was described by a young soldier in his diary: "Lt. Col Tappan sat on his horse during the charge, leisurely loading and firing his pistols as if rabbit hunting."[138]

When the campaign ended, Colonel Slough suddenly and mysteriously resigned his command. The next in line was Lieutenant Colonel Tappan, but he waived his rank in favor of Major Chivington who, after his successful raid on the Rebel supply train, was the hero of the day. Tappan was among the officers who petitioned for Chivington's promotion, and Tappan himself delivered the petition to General Canby.

Months later, Tappan wrote to Slough, asking about rumors of a murder attempt against the latter. In his stunning reply, Slough confirmed that someone had tried to assassinate him. He also implied that Chivington was involved:

I resigned the Colonelcy because I was satisfied that a further connection would result in my assassination. I am now satisfied that men now in high rank and command were at the bottom of the thing.[139]

It is unclear when Tappan knew about this and whether he stepped aside out of fear of assassination himself or if he genuinely thought that Chivington was the best man for the job at the time. Either way, the relationship between Tappan and Chivington had been deteriorating drastically.

Back from New Mexico, Tappan returned to his command at Fort Lyon. Stories soon reached his ears about negative statements that Chivington was making about him behind his back. In January 1863, Tappan confronted Chivington in a letter, berating him for trying to undermine his authority as an officer "from the earliest organization of our regiment."[140] He appealed to Chivington, for the good of the regiment, "not to exercise the power confered upon you to gratify your personal spite and sacrifice the interests of our country for the gratification of your personal ambition."[141]

Six months later, an ugly struggle arose over troop deployments between Chivington and Colonel Jesse H. Leavenworth at Fort Larned, Kansas. The Second Colorado Cavalry was already assigned to Fort Larned to help protect the Santa Fe Trail, which was being harassed by Comanche warriors. Colonel Leavenworth was in charge there and was also aware that many Colorado troops still sat idle. He requested more help from Tappan at Fort Lyon. When Chivington got wind of this, he ordered Tappan not to send any troops out of Colorado.

Shortly after, a crisis arose, and Comanches threatened to attack Fort Larned. Tappan quickly sent help to Leavenworth, disobeying Chivington's order. When Chivington heard about it, he removed Tappan from command at Fort Lyon. Leavenworth protested to his superiors:

The Fort Lyon mail is just in and I have received a note from Lieut. Col. S.F. Tappan, First Colorado Cavalry, stating that his sending me re-enforcements when I was so fearfully menaced by the Indians a few days since has been excepted to by the colonel commanding the District of Colorado, and that he has been relieved from the command of Fort Lyon in consequence. If such is the fact, I ask as a great favor of the general commanding this district that he will so represent our matters out here to General Schofield as will not only restore Colonel Tappan to his former command, but place his post, and the whole of the Santa Fe road, without [outside] the District of Colorado, if Col. J.M. Chivington is to command it any longer.[142]

Fort Garland. *Drawing by Richard Turner.*

Chivington defended himself with a long letter about the troubles he faced as commander of Colorado, pointing out that "if protected and kept quiet, [Colorado] will yield twenty millions of gold this year, and double yearly for years to come, and, in view of the national debt, I think this important, very!"[143] Although the Fort Lyon region was eventually removed from Chivington's command, for the moment, he won the argument.

On July 1, 1863, as directed by Chivington, Lieutenant Colonel Tappan took command at Fort Garland, a remote outpost west of the Sangre de Cristos in a region populated by Mexicans and the Ute nation. He brought six hundred troops with him.

Except for helping to arrange a council between Governor Evans and the Utes, Tappan's life at Fort Garland was quiet. He became aware that Mexicans in the region held thousands of Utes and Navajos as slaves and publicized the plight of these people in the Denver papers.

Beginning in the spring of 1863, the region around Fort Garland and north into South Park was terrorized by a series of mysterious murders. Finally, a wagon master near Fairplay survived and identified his attackers as two Mexican men. This incident was soon connected to a murder in Cañon City, for which authorities suspected brothers Vivian and Felipe Espinosa from New Mexico. The Espinosas, blaming white encroachment for their own troubles, began their career as desperadoes by stealing horses and robbing freight trains. This soon escalated into a murderous rampage targeted at whites. In all, the Espinosas murdered nearly thirty people.

A posse cornered them in May and killed Vivian, but Felipe escaped, returning some time later to find his brother's body. Inexplicably removing

one of Vivian's dried and shriveled feet as a souvenir, he returned to his mother's home in San Rafael, Colorado, a tiny settlement forty miles southwest of Fort Garland. There he laid low, during which time he recruited his sixteen-year-old nephew, José, as his new partner.

In early October, the duo attacked a couple riding a buggy from Trinidad to Fort Garland. Both victims managed to escape and eventually made their way to the fort.

In response, Colonel Tappan contacted well-known trapper and mountain man Tom Tobin, who lived nearby. Hiring Tobin as guide, Tappan sent Lieutenant Horace Baldwin and fifteen soldiers out after the killers on October 12, 1863. They tracked the killers into the mountains, where they eventually cornered and shot them. Baldwin later described the end of the gun battle with Espinosa: "He then raised his body enough to be visible, when he was pierced by many balls, killing him instantly. The heads of the two dead persons were severed from the bodies."[144]

Although Tobin took the heads in order to receive the advertised reward, Chivington and his ally, Jacob Downing, tried to get Baldwin court-martialed for bringing the macabre trophies back into the fort. They also tried unsuccessfully to go after Tappan for not dismissing Baldwin. This was not new. For some months, Downing, who was district inspector at the time, had been trying to make trouble for Tappan by filing numerous reports accusing him of negligence. General Curtis dismissed the charges, calling them "preposterous."

In 1864, Tappan's father died, and after many attempts, Tappan finally received permission from Chivington to travel back east. There, he visited family and met with General Ulysses S. Grant, a privilege probably arranged through his family connections. On his way back to Fort Garland in November, he broke his foot in a riding accident near Fort Lyon. There he was laid up, recovering from this injury, when Colonel Chivington arrived with the hundred days' men and launched the attack at Sand Creek.

When reports of the massacre reached the ears of officials in Washington, General Curtis replaced Chivington with Colonel Tom Moonlight. Moonlight assigned Tappan, who was the ranking officer in Colorado, to head an investigation. Chivington objected vehemently to Tappan's presence on the commission:

> *1st: That the said Lieutenant Colonel S.F. Tappan is, and for a long time past has been, my open and avowed enemy.*

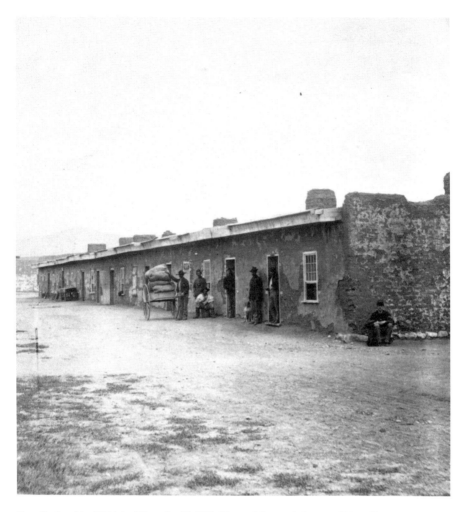

Fort Garland in 1874, by Timothy H. O'Sullivan. *Library of Congress, Prints & Photographs Division.*

2d: That the said Lieutenant Colonel S.F. Tappan has repeatedly expressed himself very much prejudiced against the killing of the Indians near Fort Lyon…and has said that it was a disgrace to every officer connected with it, and that he (Tappan) would make it appear so in the end.
3d: That I believe, from a full knowledge of his character, that he cannot divest himself of his prejudices sufficiently to render an impartial verdict.[145]

The investigation continued despite two more letters from Chivington protesting against Tappan and the commission itself. These letters, probably

written by Chivington's lawyer, Major Downing, relied on obscure legal points in an unsuccessful attempt to undermine the commission's authority.

Chivington was right about one thing: by now, Tappan despised the man. Tappan's contempt exploded in this diary entry, written during the investigation:

> *Chivington returning to Fort Lyon after the massacre of Sand Creek. In his pride and arrogance he strutted about like a cock turkey, big in his own conceit. "This," said he, "will give me the command of a Brigade." He strided up and down the room, anticipating rapid promotion for his valor on Sand Creek. He halted, placed his left foot upon a chair, his elbow upon his knee, and his face in his hand he meditated a few seconds and then exclaimed,*
>
> *"Good morning Kit Carson!"*
>
> *Then slowly and with deliberation he changed his position, to the right, and meditated as before, and exclaimed in a voice of thunder:*
>
> *"How are you Genl Harney!" He then walked the room saying "It don't take me six months to find indians." C imagined himself greater than either.*[146]

Ironically, of the three commissions assigned to look into the Sand Creek affair, Tappan was the only investigator who allowed Chivington to call witnesses on his own behalf and did not write a condemnation of Chivington's actions. Instead, Tappan merely took statements and let them stand for themselves.

In the spring of 1865, the murder of his old friend Silas Soule shocked and angered Tappan. He lamented Soule's death in his diary and referred to public statements made by Chivington:

> *The deed is done, after two attempts and many threats, Capt. Silas S. Soule was assassinated in the public streets of Denver. The author of this horrible crime may escape punishment by the hand of man, yet the real authors, those who have labored to excite by their speeches and writing this spirit of assassination in our midst, the real and responsible parties may still remain in the community. [T]he origin of this dreadful deed may yet be found in the editorial columns of the news and the public speeches of Col. Chivington. He…gave $500 to kill indians and all who sympathize with them.*[147]

Though no one ever proved that Chivington paid for Soule's assassination, many, including Tappan, clearly believed that Chivington was behind it.

Tappan contributed money to Soule's burial costs and, along with Major and Mrs. Wynkoop, accompanied Soule's widow, Hersa, to Lawrence that summer, where she went to stay with Silas's brother, William.

Tappan then continued east to Washington, D.C., where he began a career of advocating for the plains tribes. He was appointed to the Indian Peace Commission in 1867, which negotiated the Medicine Lodge Treaty. This treaty, like many others, was mostly a farce and a travesty, with the tribes relinquishing their rights to enormous swaths of territory in exchange for annuities and other assistance that rarely materialized. It created additional trouble by ignorantly placing enemy tribes together on reservations. Recognizing these problems, Tappan became a member of the United States Indian Commission, with which he worked to make sure the tribes received what was due them under the Medicine Lodge and other treaties. This was mostly a losing battle against business interests that continued to encroach on the dwindling Indian lands.

During this period, Tappan hired a young Henry M. Stanley to write articles about the commission's work—the start of an illustrious career for Stanley that eventually sent the young man to Africa in search of Dr. Livingstone.

In 1868, Tappan adopted a young Cheyenne girl who was reportedly orphaned at the Battle of Washita. Tappan named the girl Minnie and sent her to Boston, where she began her education in a public school.

The following year, he married the well-known spiritualist Cora L.V. Scott in Washington, D.C. Twenty-nine years old when she married Tappan (her third husband), Cora was a beautiful woman who had gained considerable fame as a psychic medium. She traveled the country making appearances, during which she reportedly went into a trance before delivering a "lecture." Even at a young age, she amazed audiences by speaking eloquently and voluminously about a variety of learned subjects. She authored over half a dozen books and was a subject of great curiosity for many, including Sir Arthur Conan Doyle, who wrote about her in his *History of Spiritualism*.

After Tappan's marriage to Cora, Minnie moved in with them in Washington, D.C. The family later moved to Pennsylvania, where Minnie attended prep school at Howard University. Unfortunately, about Thanksgiving 1873, Minnie became ill and died suddenly. Another spiritualist named Helen Palmer, whom Minnie called "Aunt Nellie," reportedly spoke at Minnie's funeral, insisting that Minnie's ghost appeared to her the night she died.

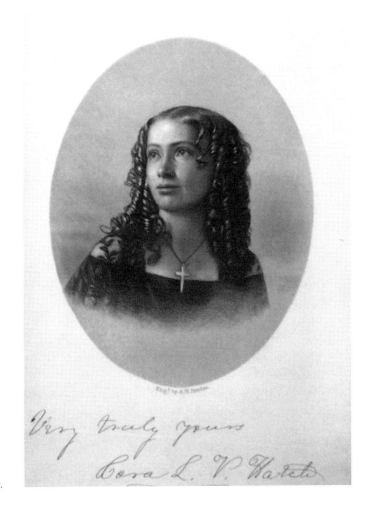

Cora Hatch, wife of Samuel Tappan. *Molly McGarry Collection.*

Samuel and Cora had no children of their own, and they divorced after seven years. In Tappan's later life, he lived as a bachelor in New York City, Oregon, California and Nebraska. He established a trade school for American Indians in Nebraska. He died on January 6, 1913, at the age of eighty-two and is buried at Arlington National Cemetery.

Chief Black Kettle

Of all those who worked for peace on the plains, there was one man who never gave up, despite having every reason to wage a total war against the whites. That man was Black Kettle, chief of the Cheyennes. Probably in his sixties at the time of Sand Creek, he went to great effort trying to control the angry young men of the Cheyenne Dog Soldiers and other warrior clans. Edward Wynkoop said that he was "the ruling spirit of his tribe, but was also looked upon by all the nomadic tribes of the plains as a superior, one whose word was law, whose advice was to be heeded."[148]

His origins are a matter of some dispute. George Bent, the son of William Bent, had married Black Kettle's niece, Magpie. He stated that Black Kettle was the son of Swift Hawk Lying Down of the Sutaio tribe, who had joined with the Cheyennes. Two other sources who knew Black Kettle well were Edward Wynkoop and General William S. Harney. These two claimed that Black Kettle was the son of High-Backed Wolf, a Cheyenne chief. Harney even stated that he (Harney) had adopted Black Kettle as a boy.

Probably born between 1800 and 1810, Black Kettle grew into manhood as a Cheyenne warrior and fought against the Kiowas, Utes and Delawares during the period between the 1830s and 1850s. By the 1860s, Black Kettle was the principal chief of the Cheyenne. Years later, Major Wynkoop described Black Kettle as "the most powerful among all the nomadic tribes; one whom I could now see, since my prejudice had fled, had been created a ruler; one who had stamped upon every liniment, the fact that he was born to command."[149]

In 1860, Black Kettle was among the chiefs who negotiated the Treaty of Fort Wise. This treaty nullified the Treaty of Fort Laramie and lessened

by nearly 90 percent the territory previously assigned to the Cheyennes and Arapahos. The treaty promised that the government would teach the tribes how to become farmers—a notion that inspired considerable skepticism among many who were familiar with their nomadic, hunting and warring lifestyle. The government would set up an agency to help in this endeavor, purchase stock, build fences, break the soil and train the Cheyennes and Arapahos how to transform themselves into an agricultural society. The treaty also called for regular annuity payments in exchange for the vast territories being ceded by the tribes. It was signed by Black Kettle, White Antelope, Lean Bear, Left Hand, Little Raven and several other chiefs.

Although it was ratified by Congress and signed by the chiefs once again that fall, the Treaty of Fort Wise quickly became a sham. The annuities were delivered only sporadically, and the federal government back east quickly became too preoccupied with the Civil War to pay much attention to setting up the agency. Many tribe members were angry when they discovered its terms and proceeded to ignore the territorial limits it imposed, saying that there were no buffalo to hunt in that region and that they would starve if they waited around for assistance from the Americans.

As tensions rose on the plains over the next few years with increased white settlement, Black Kettle remained the pragmatist and the peacemaker. Like the other "peace chiefs," he clearly knew that they were outnumbered and could not win. After the skirmishes of the first half of 1864, and after reading Governor John Evans's first proclamation, "To the Friendly Indians of the Plains," Black Kettle dictated a letter, written with the help of William Bent's son George:

Cheyenne Village, August 29, 1864:

Major Colley: We received a letter from Bent, wishing us to make peace. We held a council in regard to it. All come to the conclusion to make peace with you, providing you make peace with the Kiowas, Comanches, Apaches, and Sioux. We are going to send a messenger to the Kiowas and to the other nations about our going to make peace with you. We heard that you have some [prisoners] *in Denver. We have seven prisoners of yours which we are willing to give up, providing you give up yours. There are three war parties out yet, and two of Arapahoes. They have been out some time and expected in soon. When we held this council there were few Arapahoes and Sioux present. We want true news from you in return. That is a letter. — Black Kettle, and other Chiefs.*[150]

Like Evans, John Chivington later deconstructed this letter, attempting to prove that Black Kettle was not a peacemaker. He used somewhat dubious logic, asking, "Why did they hold a council in regard to making peace, when they were already peaceable?"[151] He also accused Black Kettle of kidnapping the white prisoners, ignoring the chief's other statements that they had traded for them.

Although it was impossible to know exactly who did what out on the vast, sparsely populated plains, George Bent said that the attacks and kidnappings in Nebraska and Kansas were perpetrated by Lakota Sioux warriors and Cheyenne Dog Soldiers. Wynkoop said in his autobiography that Dog Soldier chief Bull Bear claimed at Smoky Hill that they had "given many horses and many Buffaloe robes to other tribes for these white prisoners; we now say we will trade them for peace."[152]

At Smoky Hill, Black Kettle and Left Hand turned over four of the white hostages to Major Wynkoop. Black Kettle also said that he was trying to get hold of three others. Another hostage named Mrs. Snyder, taken by Little Raven's son, a young man of savage reputation, had killed herself in the Arapaho camp.

During the Smoky Hill Council, Black Kettle sat quietly while the other chiefs spoke. Some were in favor of making peace, and others complained that Wynkoop offered them nothing.

Wynkoop later wrote that when the others finished, Black Kettle rose and embraced him and then spoke to the other chiefs:

This white man is not here to laugh at us, nor does he regard us as children, but on the contrary unlike the balance of his race, he comes with confidence in the pledges given by the Red Man. He has been told by one of our bravest warriors, that he should come and go unharmed, he did not close his ears, but with his eyes shut followed on the trail of him whom we had sent as our messenger.

It was like coming through the fire, for a white man to follow and believe in the words of one of our race, whom they have always branded as unworthy of confidence or belief. He has not come with a forked tongue or with two hearts, but his words are straight and his heart single. Had he told us that he would give us peace, on the condition of our delivering to him the white prisoners, he would have told us a lie. For I know that he cannot give us peace, there is a greater Chief in the far off camp of the white soldiers, who must talk to one even still mightier, to our Great Father in Washington who must tell his soldiers to bury the hatchet, before we can again roam

over the Prairies in safety and hunt the buffalo. Had this white soldier come to us with crooked words, I myself would have despised him; and would have asked whether he thought we were fools, that he could sing sweet words into our ears, and laugh at us when we believed them. But he has come with words of truth; and confidence, in the pledges of his Red brothers, and whatever be the result of these deliberations, he shall return unharmed to his lodge from whence he came. It is I Moka-ta-va-tah that says it.[153]

During the Camp Weld Council, Black Kettle allowed White Antelope and Bull Bear to do much of the talking for the Cheyenne. At one point, Governor Evans addressed Black Kettle, suggesting that his people could show their good intentions by helping the white soldiers fight the Indians who were committing depredations. Black Kettle answered him:

We will return with Major Wynkoop to Fort Lyon; we will then proceed to our village and take back to my young men every word you say. I cannot answer for all of them, but think there will be but little difficulty in getting them to assent to help the soldiers.[154]

At the end of Camp Weld, Black Kettle embraced the governor and Major Wynkoop, and then all of the chiefs posed for pictures. In the Camp Weld group photo, Black Kettle is seated in the middle behind Major Wynkoop (his face partially obscured by Wynkoop's hat). Afterward, they headed back to southern Colorado, where Wynkoop advised them to move their camp close to Fort Lyon, where they could avoid trouble. Wynkoop sent a messenger to General Curtis in Leavenworth, indicating that Black Kettle and his band were willing to help him fight the Sioux, Kiowas and Comanches, who were still waging war against the whites.

Black Kettle and Left Hand set up camp near Fort Lyon as instructed. Their bands were in destitute condition, and Wynkoop ordered ten days' worth of prisoner rations for them. On November 5, Wynkoop got his answer from Curtis when Major Scott Anthony arrived at Fort Lyon with orders sending Wynkoop to district headquarters at Fort Riley, Kansas. Anthony then advised the chiefs to move their camp onto Sand Creek.

Chivington arrived with the "Bloodless Third" several weeks later. When the soldiers attacked that cold morning at Sand Creek, Black Kettle's first reaction was to hoist a large American flag and a white flag over his lodge.

Although he was mistakenly reported dead by several witnesses, Black Kettle survived the Sand Creek massacre. His wife, Woman to be

The Sand Creek site as it looks today. *Photo by Byron Strom.*

Hereafter, was shot multiple times but also survived. Although filled with "shame as big as the earth" for bringing his people to Sand Creek and for trusting the whites, Black Kettle amazingly did not give up. Within a year, he once again signed a peace treaty with the whites, the Treaty of the Little Arkansas. This provided reparations for the massacre at Sand Creek in the form of land parcels in the Arkansas Valley and Indian Territory in Oklahoma for survivors and their families. During this council, Woman to be Hereafter came in and showed them the nine gunshot wounds she had received at Sand Creek. Black Kettle spoke with a poignant mixture of optimism and fatalism:

> *Although wrongs have been done me I live in hopes. I have not got two hearts. These young men, (Cheyenne) when I call them into the lodge and talk with them, they listen to me and mind what I say. Now we are again together to make peace. My shame is as big as the earth, although I will do what my friends advise me to do. I once thought that I was the only man that persevered to be the friend of the white man, but since they have come*

and cleaned out our lodges, horses, and everything else, it is hard for me to believe white men any more.[155]

A month later, an angry Black Kettle dictated a letter to interpreter John Smith, which was published in the *Rocky Mountain News*:

> *EDITORS NEWS:*
>
> *I want to gvie* [sic] *you notice that if you don't stop calling my people "red devils," "thieving scoundrels," "women violators," "children scalpers," &c., &c., I will send Col. Tappan to "investigate" you. We are and always have been "friendly" as a people. We have some bad boys, just like white folks whom we cannot control—some of them fired into Capt Tyler's train the other day; they tried to kill his squaw and pappooses, for what he did to us last year—some of them burned the Wisconsin Ranche—and have been burning trains "and sich," but we are friendly. You see by calling us such names, the soldiers are likely to come on us and repeat "Sand Creek," and then where will you be. All these epithets you bestow on us will go back home to roost. We have Tappan and Wyncoop, and Gen. Sanborn, and the Committee on the Conduct of the War, and Bennett, and Bradford, and Henry Leach, and Gen. Slough, and his paid organ, (the Atchison Champion,) all on our side, besides a host of others, don't you see! Now you have altogether "too much acrimony." We are "intelligent, sensible people;" and very friendly. You had better keep still.*
>
> *Truly yours, BLACK KETTLE. by John Smith—Interpreter*[156]

The years after Sand Creek were fraught with increased violence on the plains, but Black Kettle managed to keep most of his band out of it. He attended and signed the Medicine Lodge Treaty in 1867, which established permanent reservations for the Southern Cheyennes and Arapahos in exchange for annuities and assistance.

As usual, the promised annuities arrived sporadically or not at all. The young warriors of the Dog Soldiers attacked white settlements and caravans. Black Kettle continued to petition for peace but admitted that he was not able to control all the young men of his tribe nor any of the Northern Cheyennes.

Black Kettle soon moved his band south to the Indian territories. On November 20, 1868, he and other "peace chiefs" met with Colonel William Hazen at Fort Cobb, Oklahoma. After the meeting, he and his band made camp on the banks of the Washita River. This camp consisted of Kiowas, Comanches, Apaches, Arapahos and Cheyennes, some of whom had

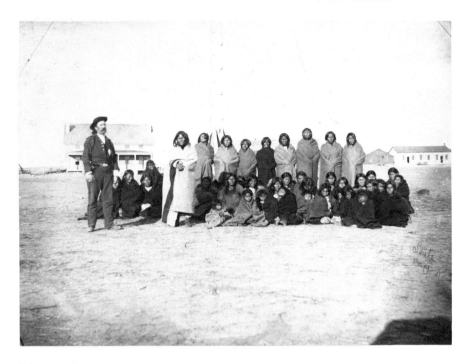

Prisoners taken after Washita, November 28, 1868. *Photo by William S. Soule. Yale Collection of Western Americana, Beinecke Rare Book and Manuscript Library.*

engaged in recent raids on white settlements. These raiders were being tracked by soldiers.

On November 26, Black Kettle held a council in his lodge, explaining to the others what they had discussed at Fort Cobb. Aware that some in the camp had been raiding the whites, Black Kettle and his band made plans to move farther south the next day.

On the morning of November 27, almost exactly four years after Sand Creek, Lieutenant Colonel George Armstrong Custer and the Seventh United States Cavalry attacked the camp at Washita. Reports on the casualties from this attack vary wildly, and once again there were eyewitness reports of atrocities, such as a pregnant woman being cut open.

Unlike at Sand Creek, Black Kettle did not bother raising a flag and trying to calm his people. He and Woman to be Hereafter jumped on a horse and tried to escape, but they were shot down in the Washita River, where they died together in the water.

EPILOGUE

In 1953, the son of Ned and Louise Wynkoop, Frank Wynkoop, wrote a notarized affidavit describing an incident that occurred between himself and John Chivington in 1894.

After Edward Wynkoop died, Louise and at least some of her children moved back to Denver. They rented a house at Thirteenth and Lawrence Streets that turned out to be two doors down from John Chivington.

The year was 1894, and the silver panic of 1893 had created desperate economic conditions in Denver. Chivington was Arapahoe County coroner at the time. According to Frank, Chivington approached the Wynkoops in a friendly manner. He gave Frank a part-time job as a member of the coroner's

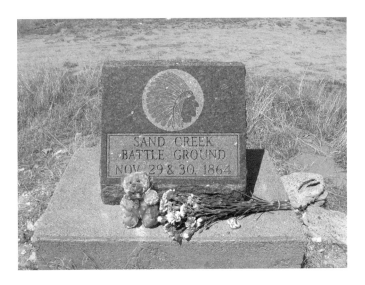

Sand Creek site marker. *Photo by Byron Strom*

jury, whose job it was to assist the coroner during inquests. One day, Frank arrived early for an inquest and was waiting in Chivington's office for the others to arrive. Frank sat on a red leather sofa while Chivington worked at his big roll-top desk. They were alone in the room together. Chivington was "six feet, seven inches tall and proportionately built in the shoulders and the rest of his body, and he had a very long, white beard at the time."[157]

Frank described what happened next:

> *I was sitting there alone—there wasn't another soul in the office—and that tall, giant Chivington got up from his desk chair and came over and sat beside me. As he reached over to me, I did not look up nor speak. He spoke into my right ear. He said, "Young man, your father was right in condemning that Sand Creek massacre."*[158]

Notes

Chief Left Hand

1. Lambert, "Plain Tales of the Plains," 20.
2. Marshall Cook manuscript, 155–56.
3. *Rocky Mountain News*, January 28, 1861.
4. *Rocky Mountain News*, April 30, 1861.
5. Ibid.

Major Edward Wynkoop

6. Wynkoop, *The Tall Chief*, 63.
7. *Rocky Mountain News*, February 12, 1862.
8. War of the Rebellion, Official Records, series 1, vol. 22, part II, 370. Cited as Rebellion Records in subsequent entries.
9. Rebellion Records, series 1, vol. 34, part IV, 151.
10. Ibid., 208.
11. Wynkoop, *The Tall Chief*, 88.
12. U.S. Senate, *"Sand Creek Massacre,"* 93. Cited as *Sand Creek Massacre* in subsequent entries.
13. *Sand Creek Massacre*, 95.
14. Ibid., 92.
15. Roberts and Halaas, "Written in Blood," 328–31.
16. *Rocky Mountain News*, October 29, 1867.

17. Letter from Wynkoop to Tappan, January 2, 1869. Samuel F. Tappan Papers. Colorado State Historical Society.
18. *Denver Republican*, September 14, 1891.

GOVERNOR JOHN EVANS

19. John Evans, as quoted in Bancroft's "Interview with John Evans."
20. Rebellion Records, series 1, vol. 22, part II, 294.
21. Grinnell, *The Fighting Cheyennes*, 128.
22. Rebellion Records, series 1, vol. 34, part IV, 100.
23. Ibid., 381.
24. Ibid., 512.
25. *Report of the Joint Special Committee*, "The Chivington Massacre," 114. Cited as Chivington Massacre in subsequent entries.
26. Ibid.
27. Rebellion Records, series 1, vol. 41, part II, 53.
28. Ibid., 644.
29. *Rocky Mountain News*, August 17, 1864.
30. *Sand Creek Massacre*, 90.
31. Ibid., 214.
32. *Report of the Joint Committee*, part III, "Massacre of Cheyenne Indians," iv. Cited as Massacre of Cheyenne Indians in subsequent entries.
33. Chivington Massacre, 80.
34. Letter from William Seward to Governor Evans, July 18, 1865. Colorado State Archives.

CAPTAIN SILAS SOULE

35. Letter from Silas Soule to Sophia Soule, January 8, 1865. Anne E. Hemphill Collection, courtesy of Byron Strom. Cited as Hemphill Collection in subsequent entries.
36. Macdonald, "She Looks Back," *Kansas City Star*, January 13, 1929.
37. Doy, *Narrative of John Doy*, 108.
38. Letter from Silas Soule to Thayre, Eldridge and Hinton, May 9, 1860, Hemphill Collection.
39. Letter from Silas Soule to "Old Friend," July 21, 1861, Hemphill Collection.

40. Letter from Silas Soule to Walt Whitman, January 8, 1862, Charles E. Feinberg Whitman Collection, Library of Congress.
41. Letter from Silas Soule to Walt Whitman, March 12, 1862, Charles E. Feinberg Whitman Collection, Library of Congress.
42. Ibid.
43. Letter from Silas Soule to Annie Soule, July 16, 1864, Hemphill Collection.
44. Letter from Silas Soule to Emily Soule, September 4, 1863, Hemphill Collection.
45. Letter from Silas Soule to Annie Soule, August 15, 1864, Hemphill Collection.
46. Letter from Silas Soule to John Chivington, October 11, 1864, "Sand Creek Papers. 1950–1971," Special Collections Department, Penrose Library, University of Denver.
47. *Sand Creek Massacre*, 10.
48. Roberts and Halaas, "Written in Blood," 328–31.
49. *Sand Creek Massacre*, 15.
50. *Sand Creek Massacre*, 21.
51. Rebellion Records, series 1, vol. 41, part I, 950.
52. *Sand Creek Massacre*, 10.
53. Letter from Hersa Soule to Annie Soule, August 6, 1865, Hemphill Collection.

Chief One Eye

54. Halaas and Masich, *Halfbreed*, 43–44.
55. Wynkoop, *The Tall Chief*, 88.
56. Ibid., 89.
57. *Sand Creek Massacre*, 30.
58. Ibid.
59. Ibid., 107.
60. Ibid.

Colonel John Chivington

61. Rebellion Records, series 1, vol. 41, part III, 596.
62. Ibid., 597.
63. *Rocky Mountain News*, December 14, 1864.

64. Massacre of Cheyenne Indians, 75.
65. Ibid.
66. Hill, *Tales of the Colorado Pioneers*, 89.

LIEUTENANT JOSEPH CRAMER

67. Letter from Silas Soule to "Old Friend," July 21, 1861, Hemphill Collection.
68. *Rocky Mountain News*, November 6, 1861.
69. *Sand Creek Massacre*, 33.
70. Ibid., 46.
71. Ibid., 47.
72. Roberts and Halaas, "Written in Blood," 328–31.
73. Ibid., 327.
74. Federal Pension File for Joseph A. Cramer, Sworn Affidavit of Edward Wynkoop, March 27, 1882, National Archives.
75. Ibid.; Deposition of Nancy Augusta Cramer Hall, October 13, 1888.

MAJOR SCOTT ANTHONY

76. Rebellion Records, series 1, vol. 22, part II, 572.
77. Ibid.
78. Rebellion Records, series 1, vol. 41, part I, 912.
79. Ibid., 913.
80. Ibid., 914.
81. Ibid., 951–52.
82. Chivington Massacre, 153.
83. Rebellion Records, series 1, vol. 41, part I, 952.
84. Ibid., 953.
85. Ibid., 954.
86. Massacre of Cheyenne Indians, 16.
87. Ibid., 18.
88. Ibid.
89. Ibid., 26.
90. Ibid., 27.
91. *Daily Mining Journal*, January 5, 1865.

Chief White Antelope

92. Hamilton, *My Sixty Years on the Plains*, 24.
93. Ibid., 30.
94. Ibid., 192.
95. Ibid., 31.
96. Chivington Massacre, 88.
97. Ibid.
98. Ibid., 89.
99. Ibid., 73.
100. Ibid., 67.
101. Ibid., 96.
102. Ibid., 76.

William Bent

103. Magoffin, *Down the Santa Fe Trail*, 60.
104. Ibid., 66.
105. Ibid., 68.
106. Chivington Massacre, 96.
107. Ibid.
108. Ibid., 94.
109. Halaas and Masich, *Halfbreed*, 268.

Major Jacob Downing

110. Dexheimer, "Grave Reservations," 1.
111. Chivington Massacre, 70.
112. Ibid., 69.
113. Rebellion Records, series 1, vol. 34, part III, 252.
114. Ibid., 407.
115. Chivington Massacre, 69.
116. Ibid.
117. Ibid.
118. *Sand Creek Massacre*, 126.
119. Rebellion Records, series 1, vol. 34, part I, 908.
120. *Sand Creek Massacre*, 116.

121. Chivington Massacre, 69.
122. Ibid.
123. Ibid., 70.
124. Ibid.
125. *Rocky Mountain News*, April 14, 1865.
126. Ibid., October 24, 1865.
127. Ibid., December 15, 1871.
128. *Aspen Times*, May 13, 1882.

Lieutenant James Cannon

129. *Sand Creek Massacre*, 110.
130. Ibid.
131. Ibid., 115.
132. *Daily Mining Journal*, April 25, 1865.
133. Ibid., June 14, 1865.
134. Ibid., April 28, 1865.
135. *Rocky Mountain News*, July 18, 1865.
136. Ibid.

Lieutenant Colonel Samuel F. Tappan

137. *Daily Colorado Republican and Rocky Mountain Herald*, August 26, 1861.
138. Hollister, *Colorado Volunteers in New Mexico*, 114.
139. Letter from John Slough to Samuel Tappan, in Goertner, "Reflections of a Frontier Soldier," 29.
140. Ibid., 31.
141. Ibid.
142. Rebellion Records, series 1, vol. 22, part II, 401.
143. Ibid., 528.
144. Rebellion Records, series 1, vol. 22, part I, 705.
145. *Sand Creek Massacre*, 5.
146. Samuel Tappan diary, 48–49, in Goertner, "Reflections of a Frontier Soldier," 108.
147. Ibid., 251–52.

Chief Black Kettle

148. *New York Times*, December 24, 1868.

149. Wynkoop, *The Tall Chief*, 91.

150. Chivington Massacre, 79.

151. Ibid.

152. Wynkoop, *The Tall Chief*, 91.

153. Ibid., 30–31.

154. *Sand Creek Massacre*, 215.

155. *Annual Report of the Commissioner of Indian Affairs, 1865*, 704–5.

156. *Rocky Mountain News*, November 14, 1865.

Epilogue

157. Affidavit of Frank Wynkoop, December 1953. Samuel F. Tappan Papers. Yale Collection of Western Americana, Beinecke Rare Book and Manuscript Library.

158. Ibid.

BIBLIOGRAPHY

BOOKS

Bancroft, Hubert H. "Interview with John Evans." Reprinted in McMechen, Edgar Carlisle. *Life of Governor Evans: Second Territorial Governor of Colorado*. Denver, CO: privately printed, 1924.

Barker, Anselm Holcomb, and Nolie Mumey. *Anselm Holcomb Barker, 1822–1895, Pioneer Builder and Early Settler of Auraria: His Diary of 1858 from Plattsmouth, Nebraska Territory, to Cherry Creek Diggings, the Present Site of Denver, Colorado*. Denver, CO: Golden Bell, 1959.

Barrett, H.D. *The Life Work of Cora L.V. Richmond*. Harry Houdini Collection, Library of Congress. Chicago, IL: Hack & Anderson, 1895.

Byers, William N. "Scott J. Anthony." *Encyclopedia of Biography of Colorado*. Chicago, IL: Century and Engraving Company, 1901.

Coel, Margaret. *Chief Left Hand: Southern Arapaho*. Norman: University of Oklahoma, 1982.

Craig, Reginald. *The Fighting Parson: The Biography of Colonel John M. Chivington*. Los Angeles, CA: Westernlore Press, 1959.

Doy, John. *The Narrative of John Doy, of Lawrence, Kansas...* New York: T. Holman, Printer, 1860.

Grinnell, George Bird. *The Fighting Cheyennes*. New York: Charles Scribner's Sons, 1915.

Halaas, David F., and Andrew E. Masich. *Halfbreed: The Remarkable True Story of George Bent*. Cambridge, MA: Da Capo, 2004.

Hamilton, W.T. *My Sixty Years on the Plains: Trapping, Trading, and Indian Fighting*. New York: Forest and Stream Pub., 1905.

Hill, Alice Polk. *Tales of the Colorado Pioneers*. Glorieta, NM: Rio Grande, 1976.

Hoig, Stan. *The Peace Chiefs of the Cheyennes*. Norman: University of Oklahoma, 1980.

———. *The Sand Creek Massacre*. Norman: University of Oklahoma, 1961.

———. *The Western Odyssey of John Simpson Smith*. Norman: University of Oklahoma, 2004.

Hollister, Ovando J. *Colorado Volunteers in New Mexico, 1862*. Chicago, IL: R.R. Donnelley & Son's Company, 1962.

Lambert, Julia S. *Plain Tales of the Plains*. Denver, CO: Trail, 1916.

Lavender, David Sievert. *Bent's Fort*. Lincoln: University of Nebraska, 1972.

Lee, Wayne C., and Howard C. Raynesford. *Trails of the Smoky Hill: From Coronado to the Cow Towns*. Caldwell, ID: Caxton Printers, 1980.

Magoffin, Susan S. *Down the Santa Fe Trail and into Mexico: The Diary of Susan Shelby Magoffin*. Edited by Stella M. Drumm. New Haven, CT: Yale University Press, 1965.

Mumey, Nolie. *Early Settlements of Denver*. Glendale, CA: Arthur H. Clark, 1942.

Ostrander, Romine H., and Paul A. Malkoski. *This Soldier Life: The Diaries of Romine H. Ostrander, 1863–1865, in Colorado Territory*. Denver: Colorado Historical Society, 2006.

Perkins, James E. *Tom Tobin: Frontiersman*. Pueblo West, CO: Herodotus, 1999.

Roberts, Gary L., and David F. Halaas. "Written in Blood: The Soule-Cramer Sand Creek Massacre Letters." Reprinted in *Western Voices: 125 Years of Colorado Writing*. Edited by Ben Fogelberg. Golden, CO: Fulcrum, 2004.

Sides, Hampton. *Blood and Thunder: An Epic of the American West*. New York: Anchor, 2007.

Ubbelohde, Carl, Maxine Benson and Duane A. Smith. *A Colorado History*. Boulder, CO: Pruett, 1965.

Utley, Robert Marshall, and Wilcomb E. Washburn. *Indian Wars*. Boston, MA: Houghton Mifflin, 2002.

Wynkoop, Edward W. *The Tall Chief: The Autobiography of Edward W. Wynkoop*. Edited by Christopher B. Gerboth. Denver: Colorado Historical Society, 1993.

GOVERNMENT DOCUMENTS

The National Archives and Records Administration (NARA). Federal Pension File for Joseph A. Cramer, December 22, 1879. National Archives.

U.S. Congress. Senate. *Report of the Joint Committee on the Conduct of the War.* Part III. "Massacre of Cheyenne Indians."

————. *Report of the Joint Special Committee Appointed Under Resolution of March 3, 1865.* "The Chivington Massacre."

————. *"Sand Creek Massacre"; Report of the Secretary of War.* Sen. Exec. Doc. 26, 39th Congress, 2nd Session. Washington, D.C., 1867.

U.S. Department of the Interior. Bureau of Indian Affairs. *Annual Report of the Commissioner of Indian Affairs, 1865.* Washington, D.C.: U.S. Department of the Interior.

U.S. War Department. War of the Rebellion: Official Records of the Union and Confederate Armies. Washington, D.C.

Magazine and Newspaper Articles

Dexheimer, Eric. "Grave Reservations." *Westword,* July 24, 1997. http://www.westword.com/1997-07-24/news/grave-reservations.

Macdonald, A.B. "She Looks Back Seventy-Five Years." *Kansas City (MO) Star,* January 13, 1929.

Manuscripts and Collections

Carey, Raymond G., comp. "Sand Creek Papers. 1950–1971." Special Collections Department, Penrose Library, University of Denver, Denver, Colorado.

Clark, Bonnie J. "Amache Ochinee Prowers: The Archaeobiography of a Cheyenne Woman." Thesis, University of Denver.

Goertner, Thomas Grenville. "Reflections of a Frontier Soldier on the Sand Creek Affair as Revealed in the Diary of Samuel F. Tappan." Thesis, Penrose Library/University of Denver, 1959.

The Letters of Silas Soule, 1861–65. Anne E. Hemphill Collection, Des Moines, Iowa. Courtesy of Byron Strom.

Marshall Cook manuscript. Colorado State Historical Society, Denver, Colorado.

Samuel F. Tappan Papers. Yale Collection of Western Americana, Beinecke Rare Book and Manuscript Library. Yale University, New Haven, Connecticut.

Seward, William. Letter to Governor John Evans, July 18, 1865. Colorado State Archives, Denver, Colorado.

Soule, Silas. Letters to Walt Whitman, 1862. Charles E. Feinberg Whitman Collection, Library of Congress.

Wynkoop, Edward. Letter to Samuel Tappan. January 2, 1869. Samuel Tappan Papers. Colorado Historical Society, Denver, Colorado.

NEWSPAPERS

Aspen (CO) Times.
Central City (CO) Daily Mining Journal.
Daily Colorado Republican.
Denver Republican.
Denver (CO) Rocky Mountain Herald.
Denver (CO) Rocky Mountain News.

WEBSITES

Cahill, Kevin. "Edward W. Wynkoop." Lone Wolf, 2005. http://www.kclonewolf.com/History/SandCreek/Bio/edward-wynkoop-biography.html.

Sangres.com. "The Women of Boggsville, Colorado." http://www.sangres.com/history/boggsvillewomen.htm.

Wikipedia. "Samuel F. Tappan," October 30, 2005. http://en.wikipedia.org/wiki/Samuel_F._Tappan.

Wynkoop, Christopher H. "Edward Wanshaer Wynkoop." Ancestry.com, August 11, 2007. http://freepages.genealogy.rootsweb.ancestry.com/~wynkoop/webdocs/nedwkp.htm.

ABOUT THE AUTHOR

Carol Turner has a BA in English from Sonoma State University and an MFA in creative writing and literature from Bennington College. She is the author of *Economics for the Impatient*, and her short fiction has appeared in numerous literary magazines. She lives in Colorado, writes a history column for the *Broomfield Enterprise* and maintains a Colorado history blog at http://caturner.wordpress.com.

Visit us at
www.historypress.net